Royal
Botanic
Gardens **Kew**

THE ROYAL BOTANIC GARDENS, KEW

Fabulous Flowers

COLORING BOOK

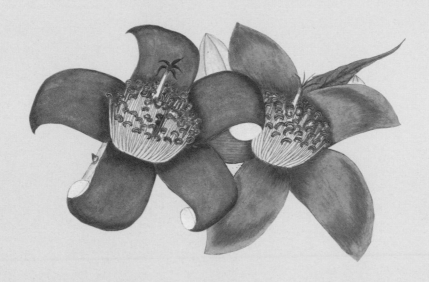

SIRIUS

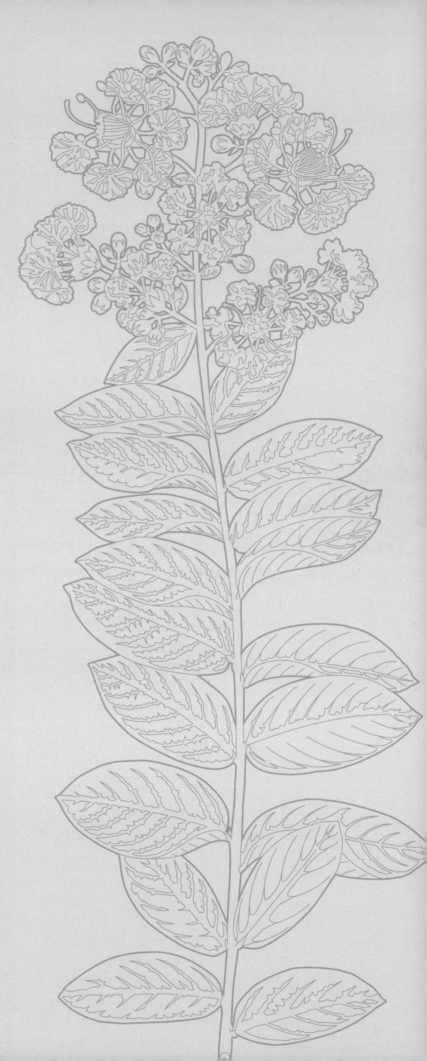

Royal Botanic Gardens Kew

All illustrations included in this book have been taken from the Library and Archives Collections of the Royal Botanic Gardens, Kew.

SIRIUS

This edition published in 2024 by Sirius Publishing, a division of Arcturus Publishing Limited,
26/27 Bickels Yard, 151–153 Bermondsey Street,
London SE1 3HA

Copyright © Arcturus Holdings Limited

ISBN: 978-1-3988-3618-1
CH011169NT

Printed in China

FSC
www.fsc.org

MIX
Paper | Supporting
responsible forestry
FSC® C016973

Introduction

The plants selected for inclusion in this coloring book are taken from what is known as the Roxburgh Collection that is held in the archives of the Royal Botanic Gardens, Kew. The collection is named after Dr. William Roxburgh (1751–1815), a ship's surgeon who hailed from Ayrshire in Scotland.

All the artworks were commissioned by Roxburgh from local artists in India during the late 18th century when he became the East India Company's botanist in Madras (now Tamil Nadu). Over the course of some years, while he was conducting botanical experiments, Roxburgh built up a collection that stretched to more than 900 illustrations, many of which he sent to Sir Joseph Banks, the Director of the Royal Botanic Gardens, Kew, for his comments and they were then published in Roxburgh's three-volume work, *Plants of the Coast of Coromandel* (1795–1819).

In 1789, Roxburgh was appointed to the position of Naturalist to the Madras Government. He continued his research into the climate of the area, and he amassed a huge amount of meteorological data that was used to support his medical interests and the theories that he developed regarding famine and climate change in the British Empire. This interest led Roxburgh to help set up a garden at a village called Corcondah (now in the state of Telangana in the southeast of central India) that specialized in researching crops which could both survive the climate and provide food.

Roxburgh lost his initial research material in a devastating flood that destroyed his home and all his possessions in 1787, but he rebuilt his collection, which included both botanical drawings and plant specimens, and in 1793, he became Superintendent of the Calcutta Botanic Garden. His contribution to the study of Indian botany, and to economic botany in particular, led to his becoming known as "the Father of Indian Botany."

Although Roxburgh paid privately for some 900 drawings to be made, sadly, the names of the artists who produced the illustrations were never recorded, but it is highly likely that they would have been trained in the Mughal tradition of miniature painting and so used to producing very detailed work. Given the demand for botanic art from visiting Europeans, the local artists adapted their work to produce images on a larger scale and stylistically somewhat closer to the work of well-known European artists such as Pierre-Joseph Redouté and Mark Catesby. The images contained in this collection represent a diverse range of plants that include both ornamental waterlilies and plants that would have been cultivated for food.

Key: List of plates

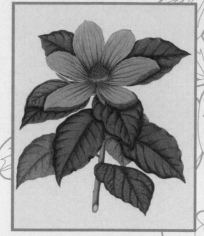

1 *Magnolia obovata*

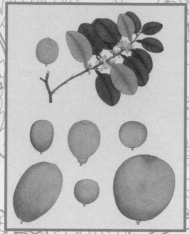

2 *Citrus medica*

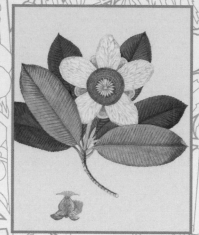

3 *Dillenia reifferscheidia*

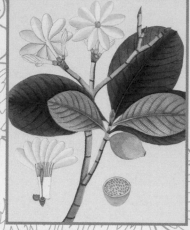

4 *Gardenia latifolia*

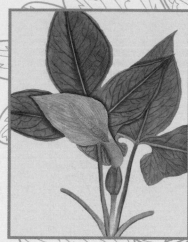

5 *Arum orixensis*

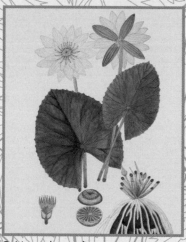

6 *Nymphaea lotus*

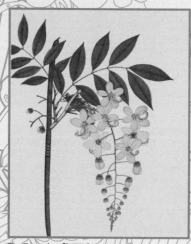

7 *Cassia fistula*

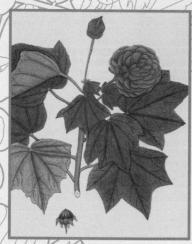

8 *Hibiscus mutabilis*

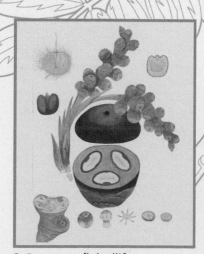

9 *Borassus flabellifer*

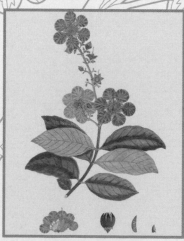

10 *Lagerstroemia speciosa* subsp. *speciosa*

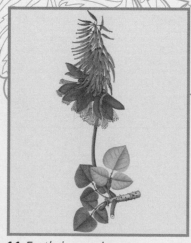

11 *Erythrina variegata*

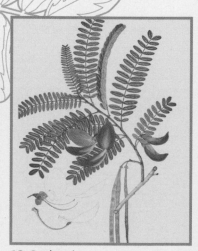

12 *Sesbania grandiflora*

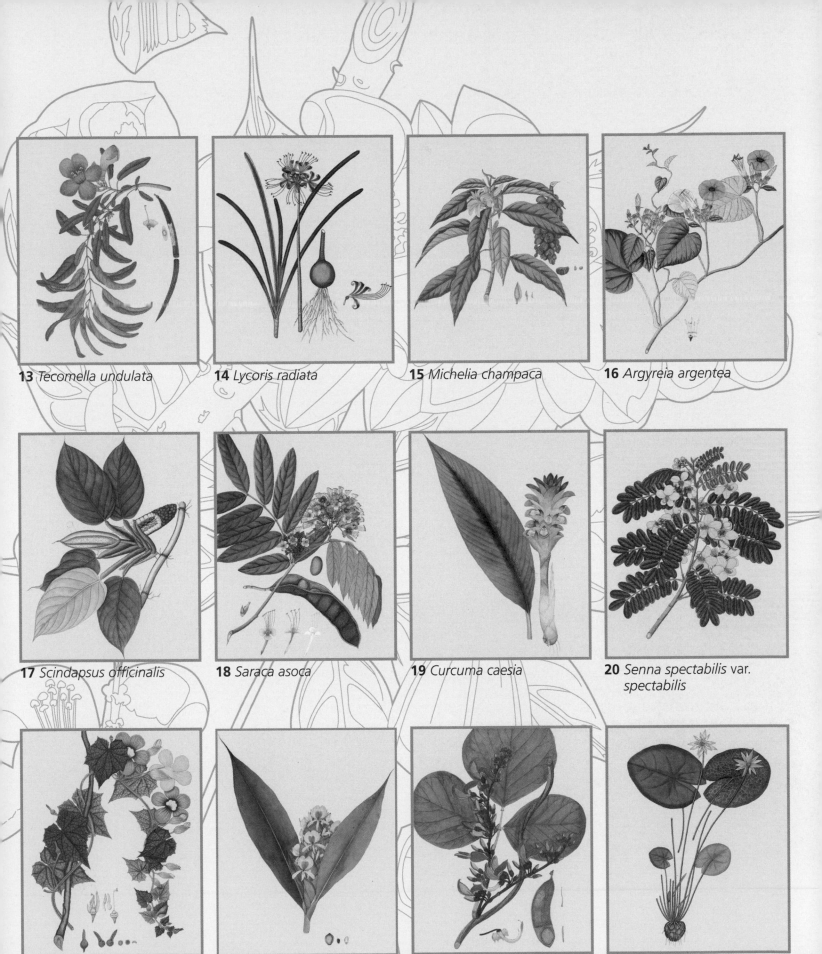

13 *Tecomella undulata*

14 *Lycoris radiata*

15 *Michelia champaca*

16 *Argyreia argentea*

17 *Scindapsus officinalis*

18 *Saraca asoca*

19 *Curcuma caesia*

20 *Senna spectabilis* var. *spectabilis*

21 *Thunbergia grandiflora*

22 *Hedychium flavum*

23 *Butea superba*

24 *Nymphaea nouchali* var. *nouchali*

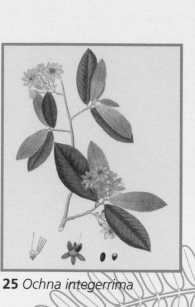

25 *Ochna integerrima*

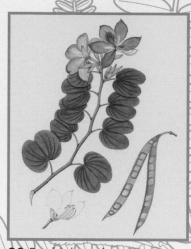

26 *Bauhinia variegata*

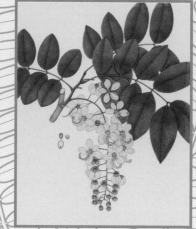

27 *Cassia fistula*

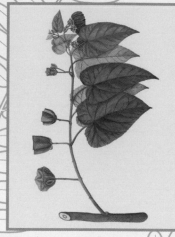

28 *Abroma augustum*

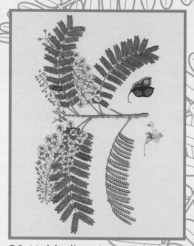

29 *Hultholia mimosoides*

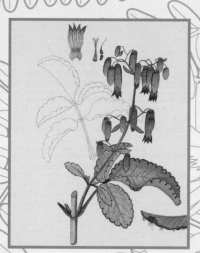

30 *Kalanchoe pinata*

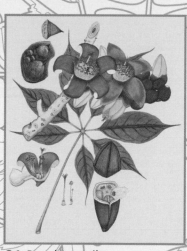

31 *Bombax ceiba*

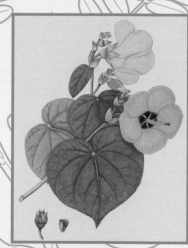

32 *Hibiscus tiliaceus*

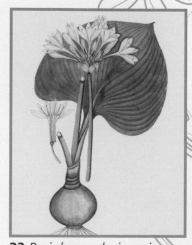

33 *Proiphys amboinensis*

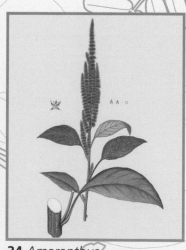

34 *Amaranthus hypochondriacus*

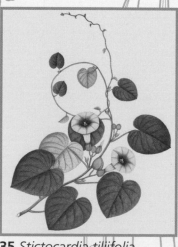

35 *Stictocardia tiliifolia*

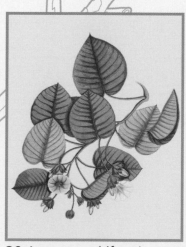

36 *Argyrea capitiformis*

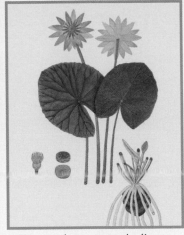

37 *Nymphaea nouchali* var. *nouchali*

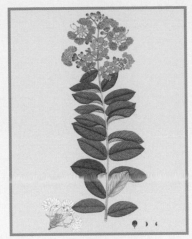

38 *Lagerstroemia indica*

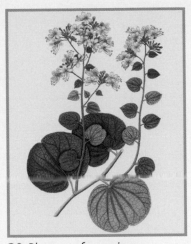

39 *Phanera ferruginea*

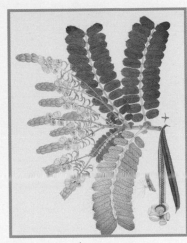

40 *Senna alata*

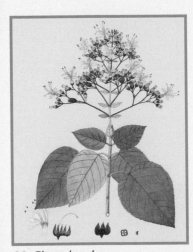

41 *Clerodendrum infortunatum*

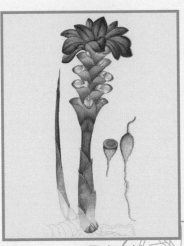

42 *Curcuma zanthorrhiza*

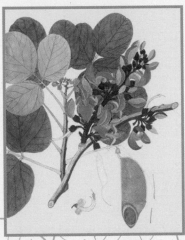

43 *Butea monosperma*

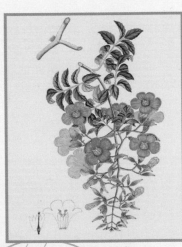

44 *Bignonia grandiflora*

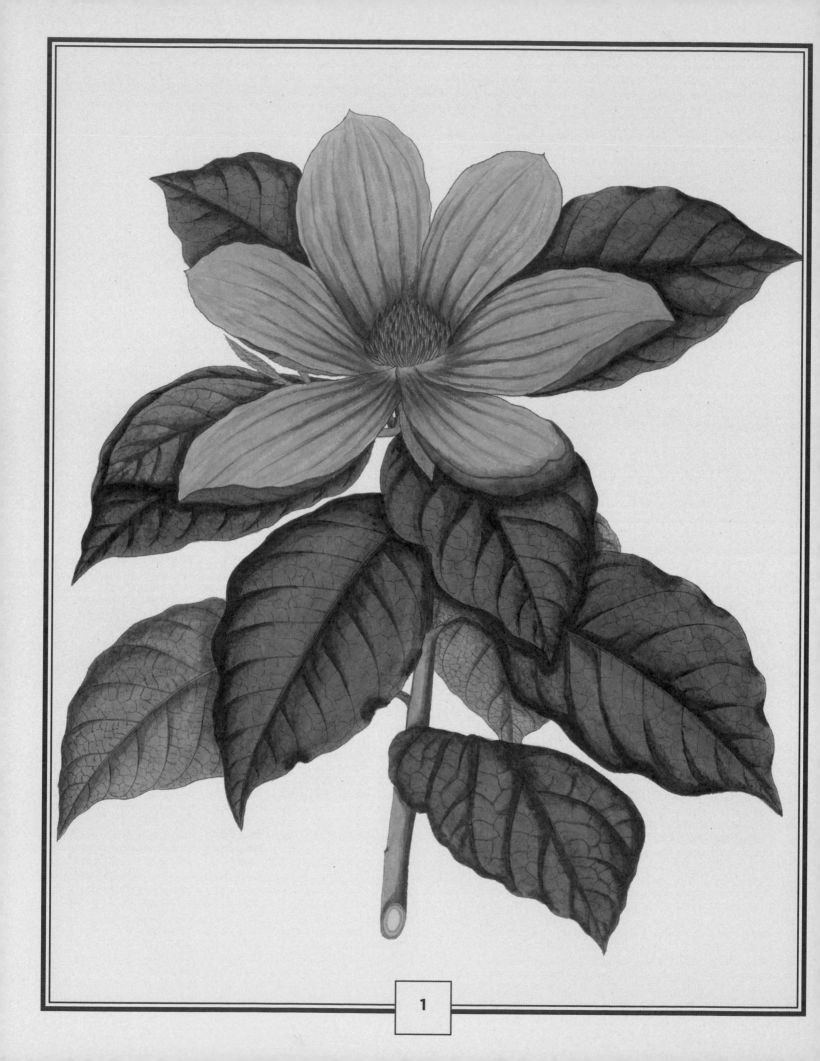

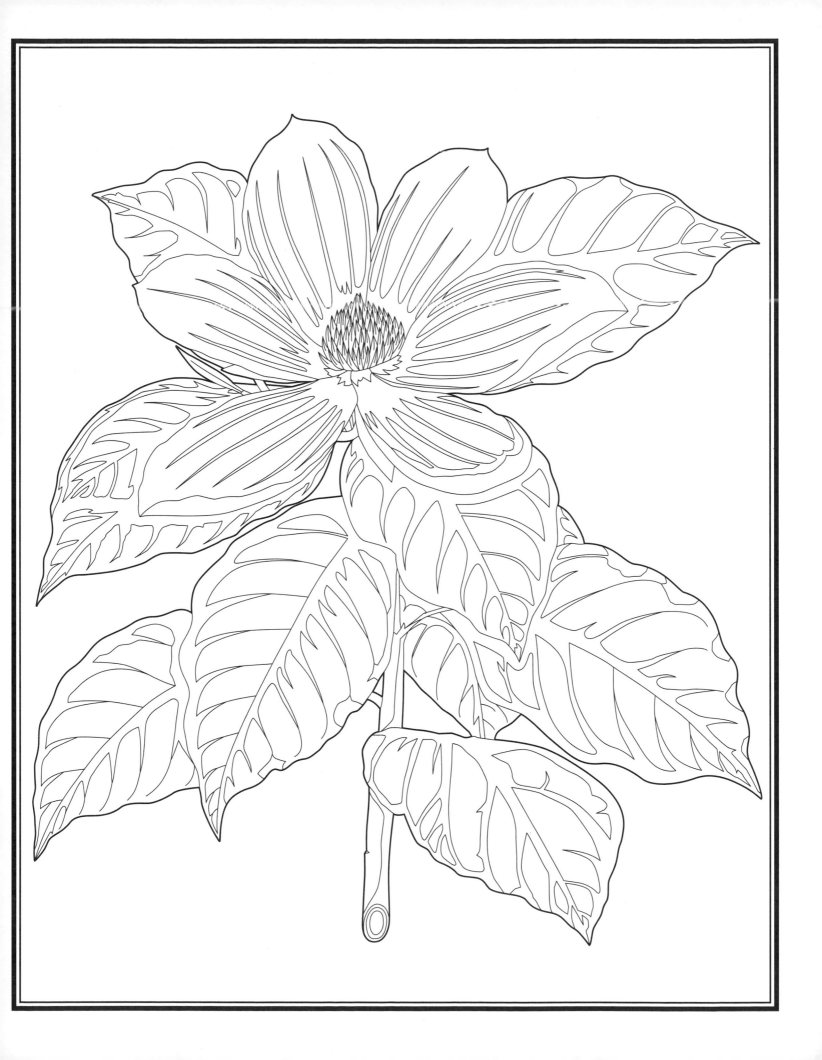

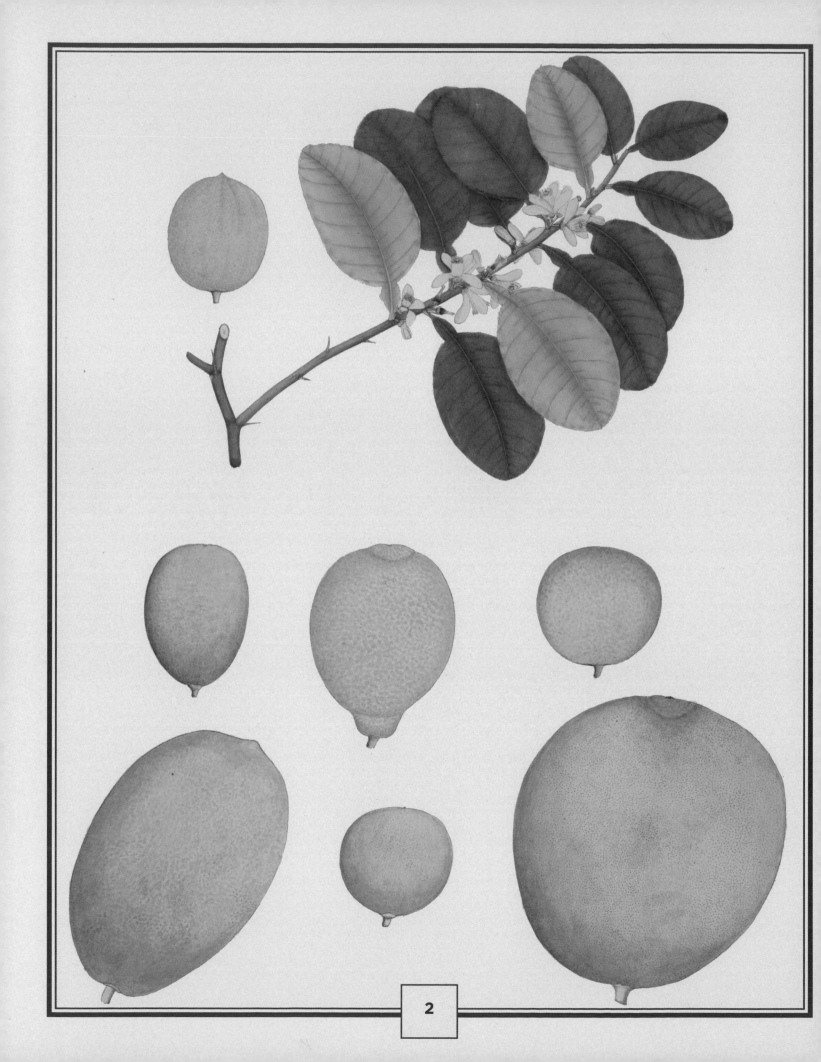

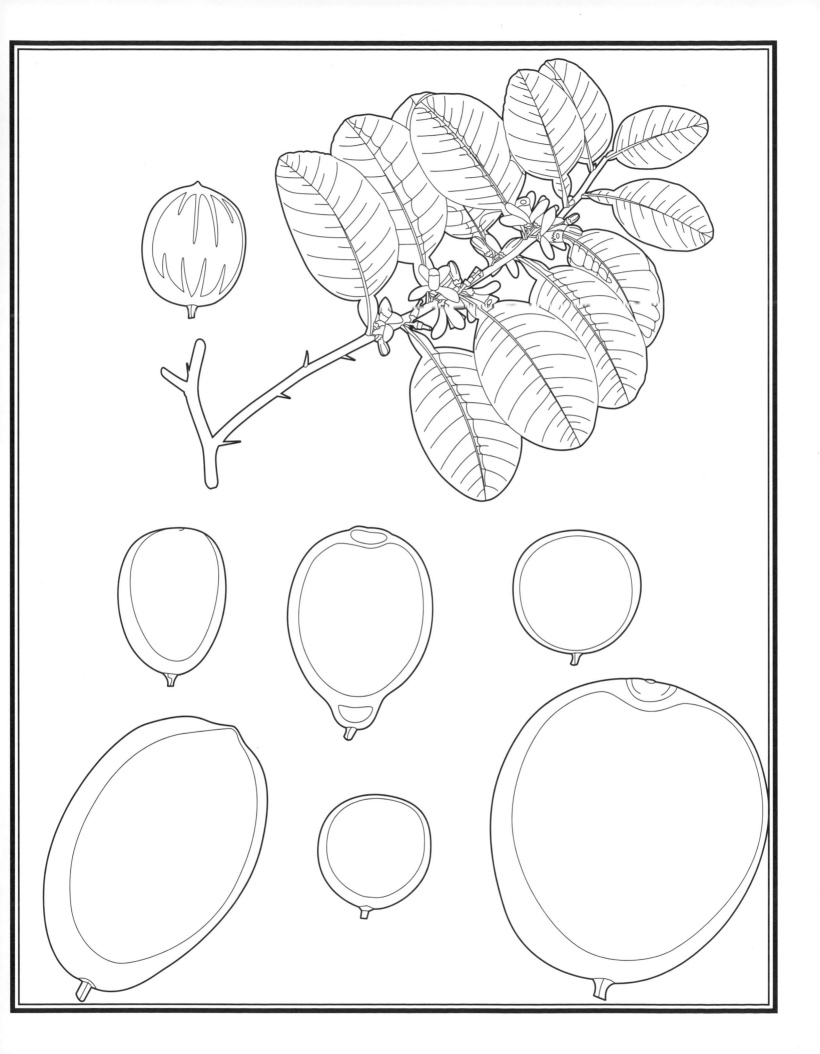

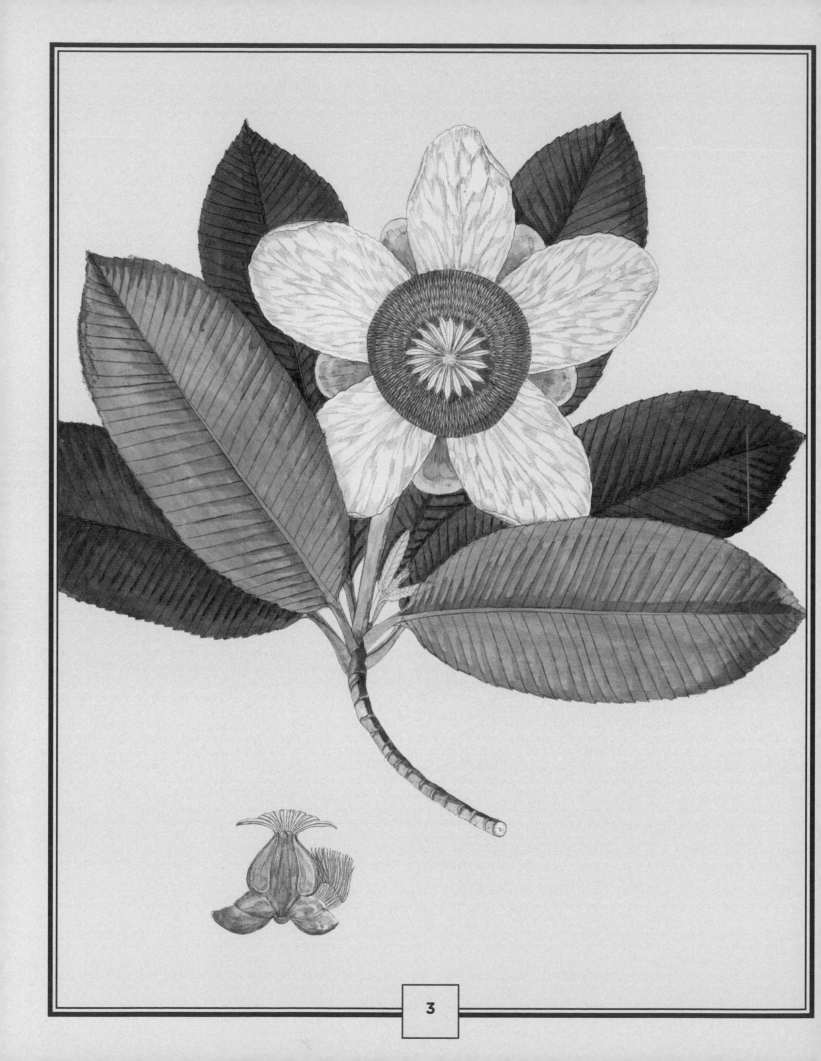

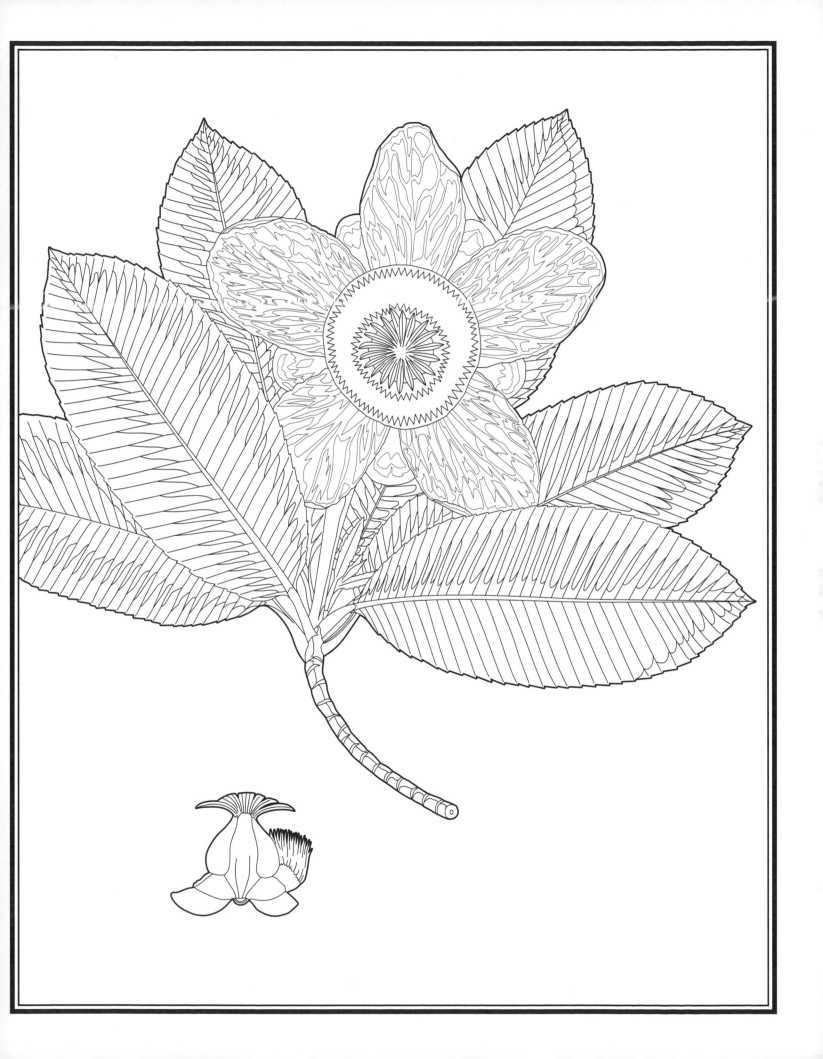

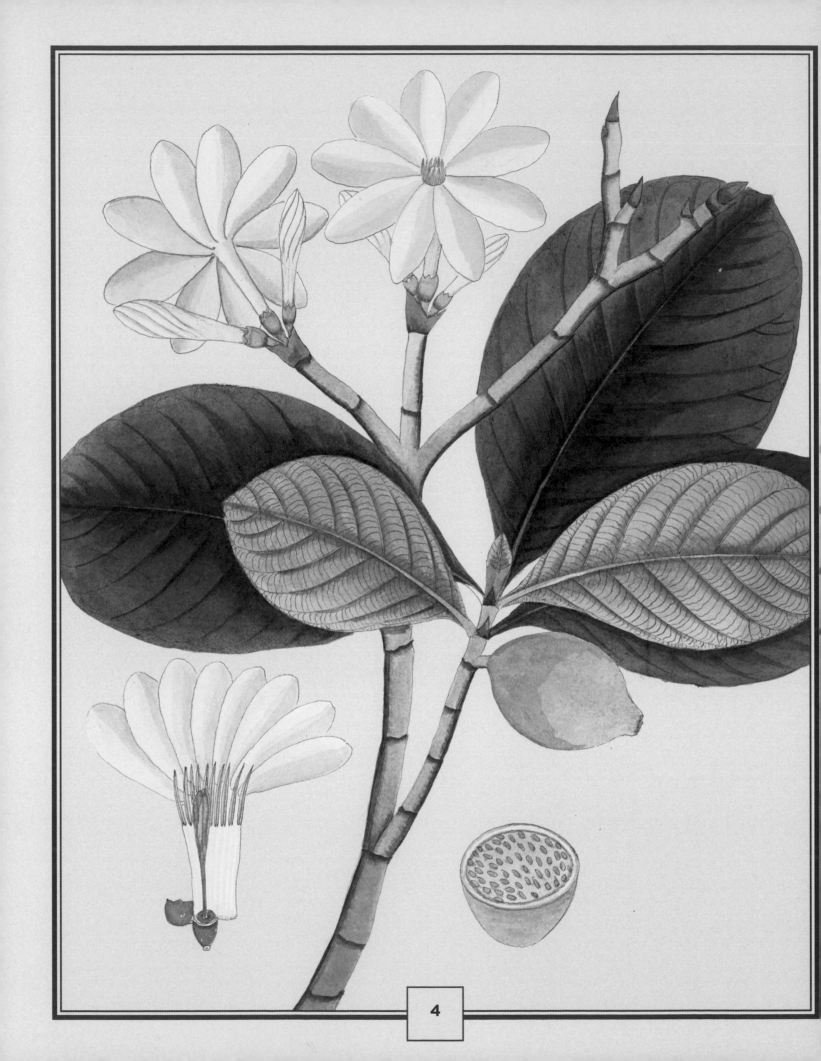

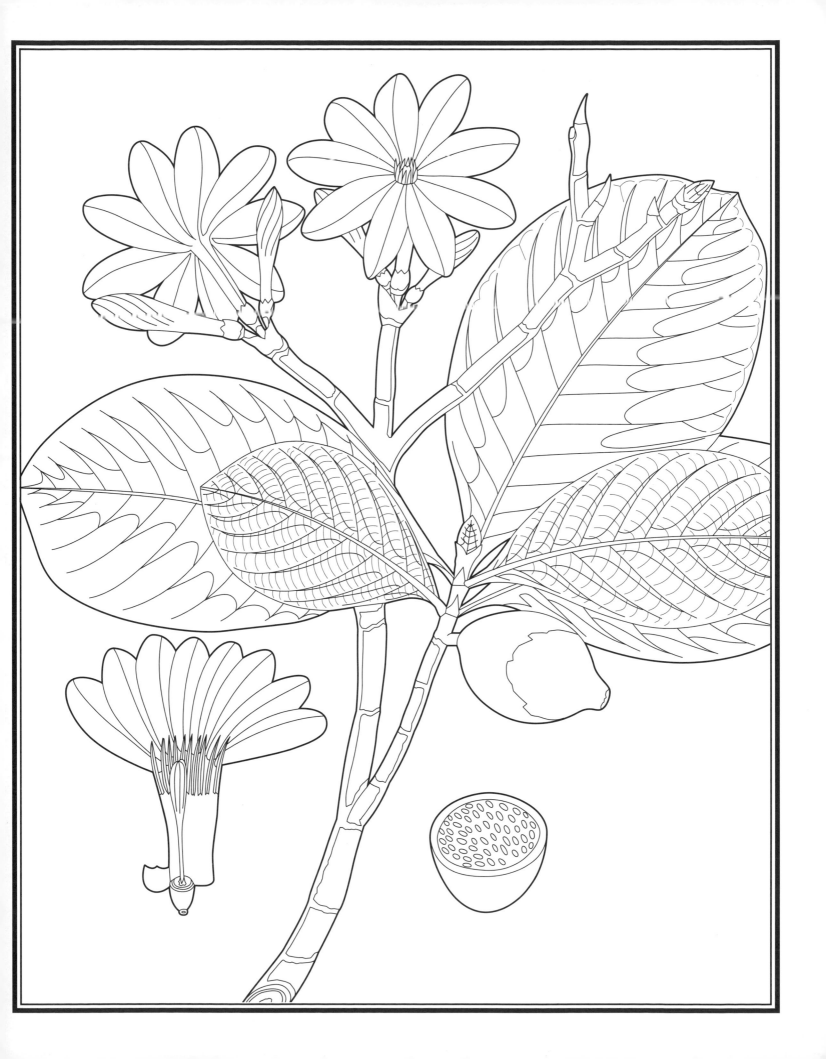

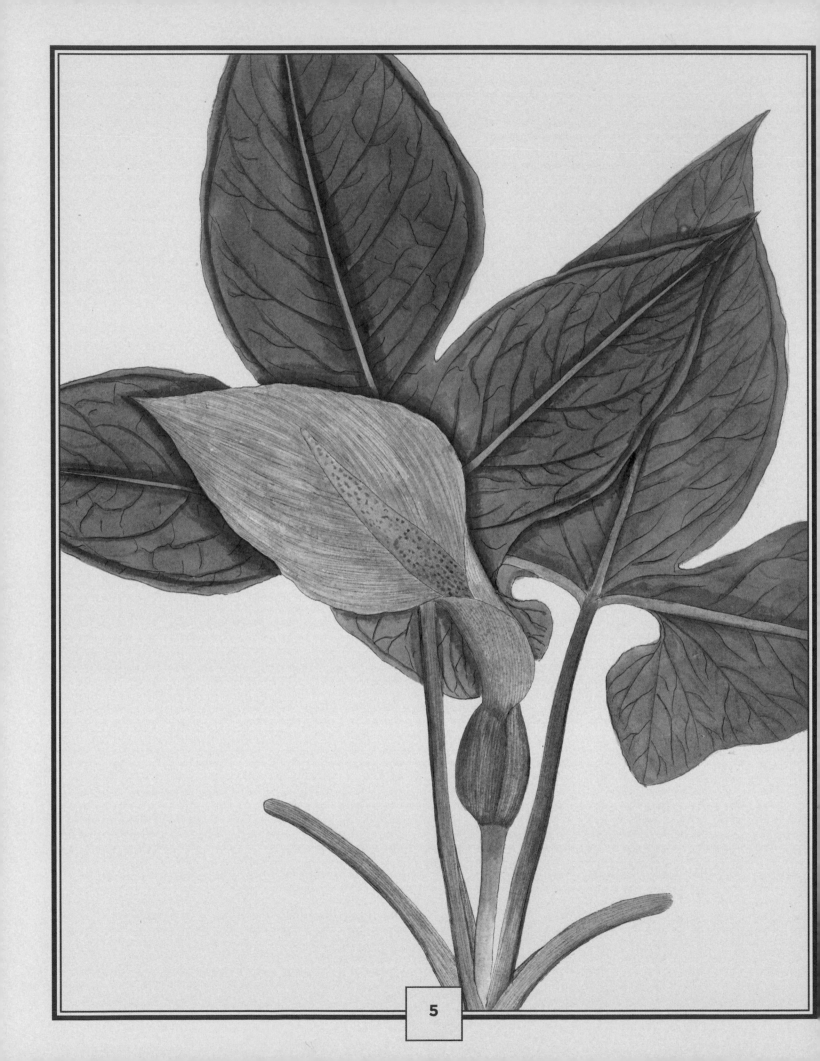

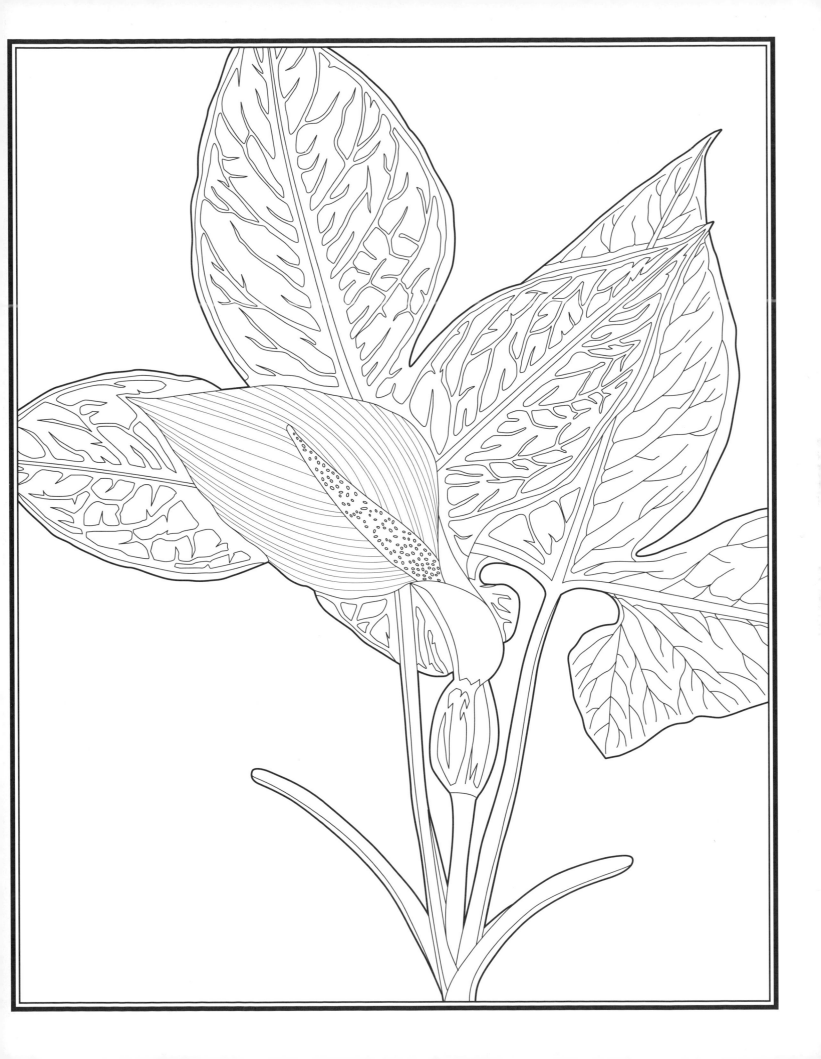

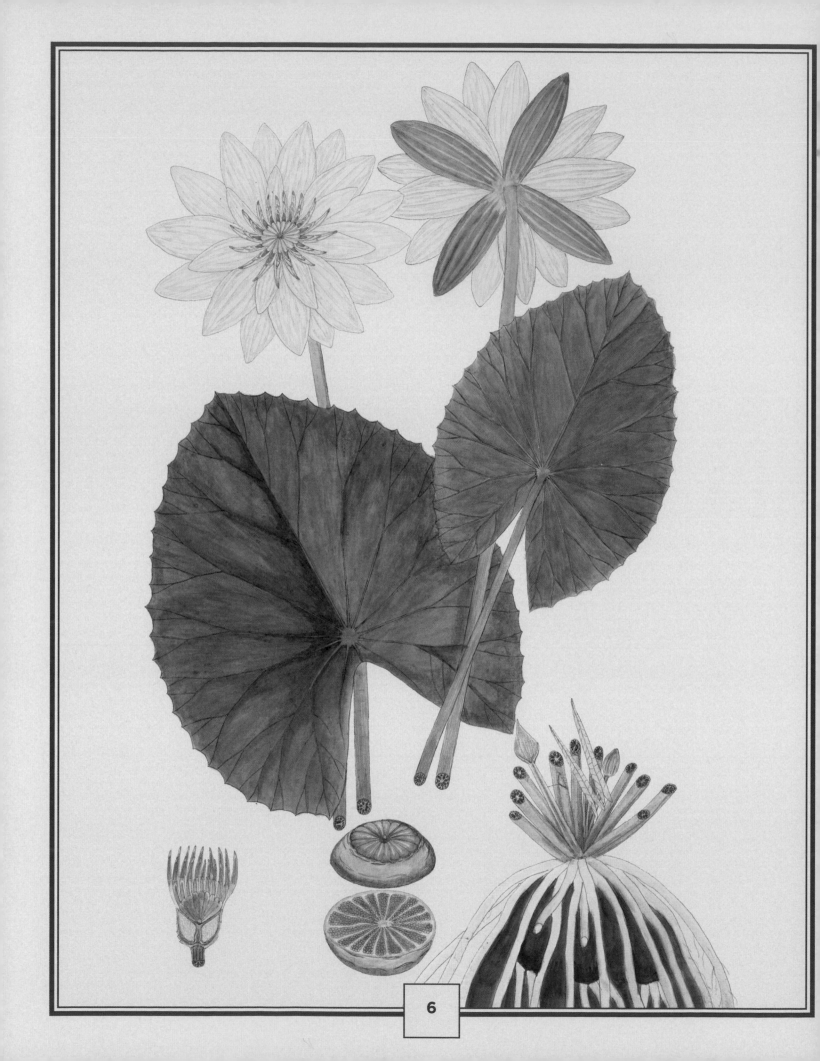

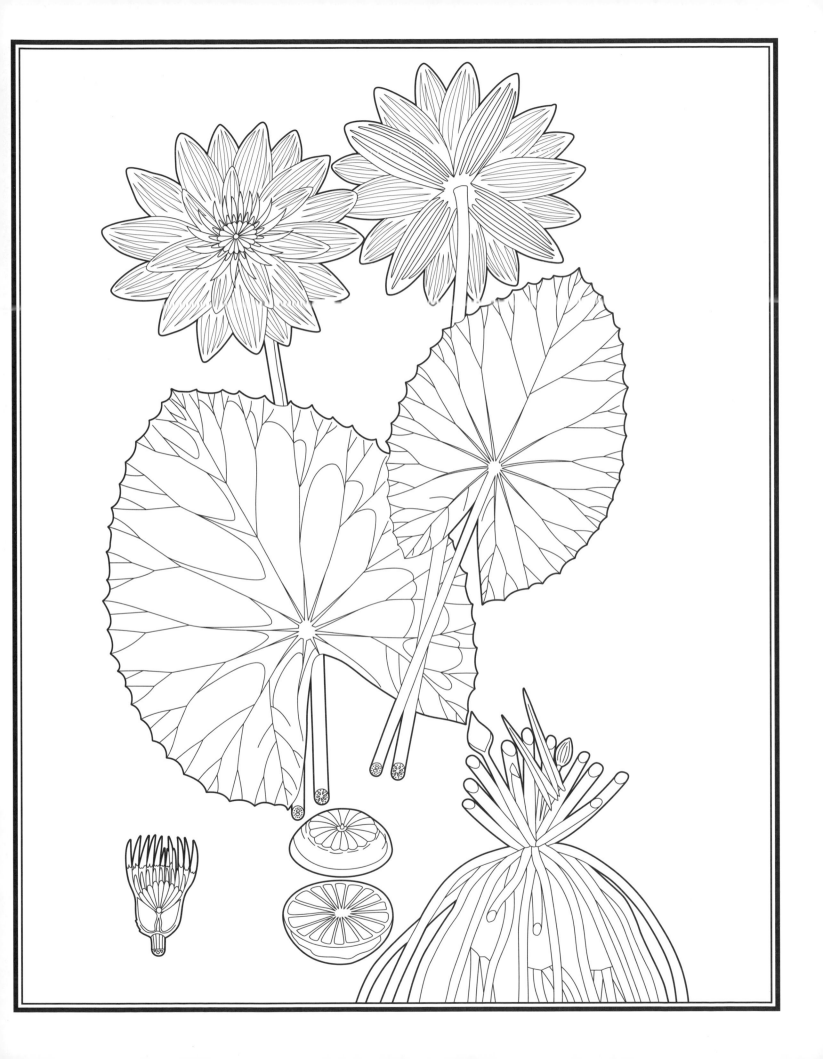

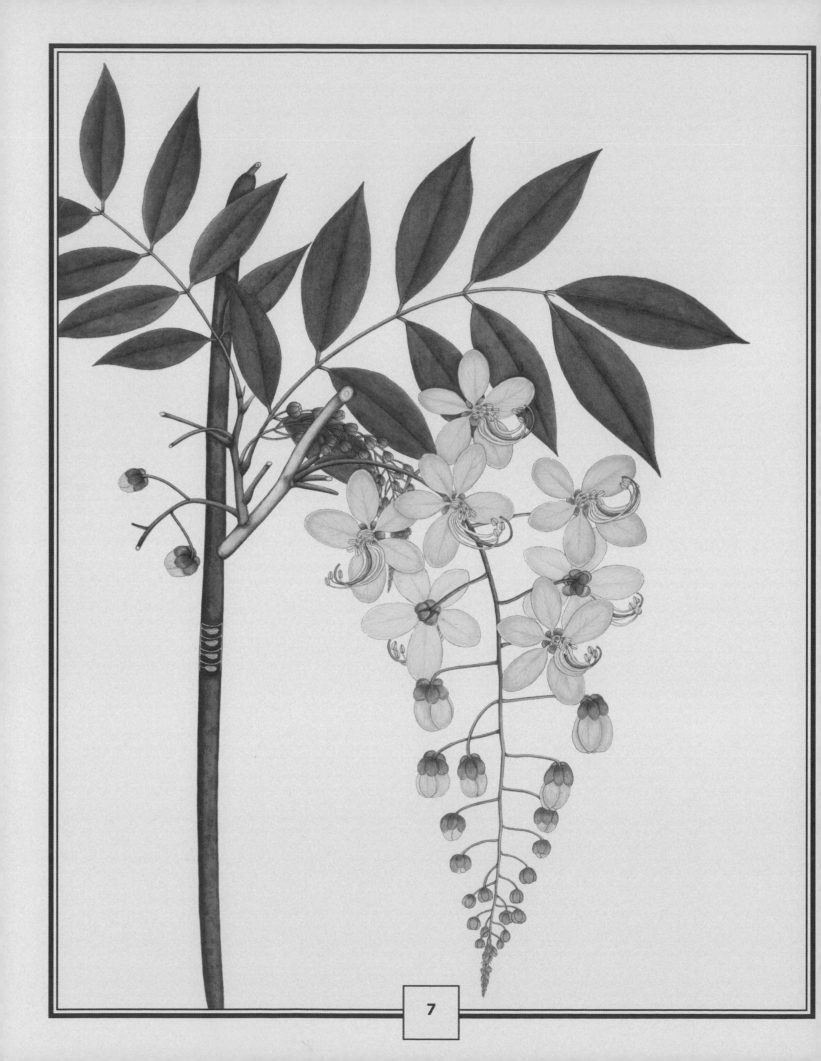

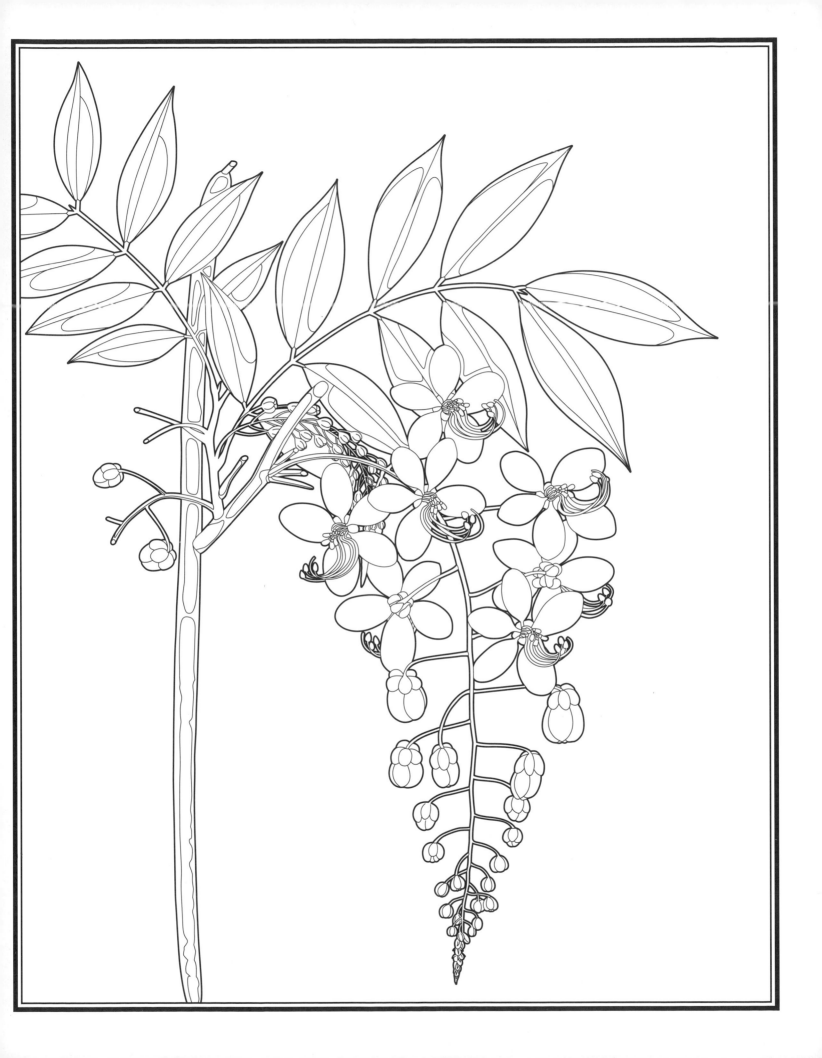

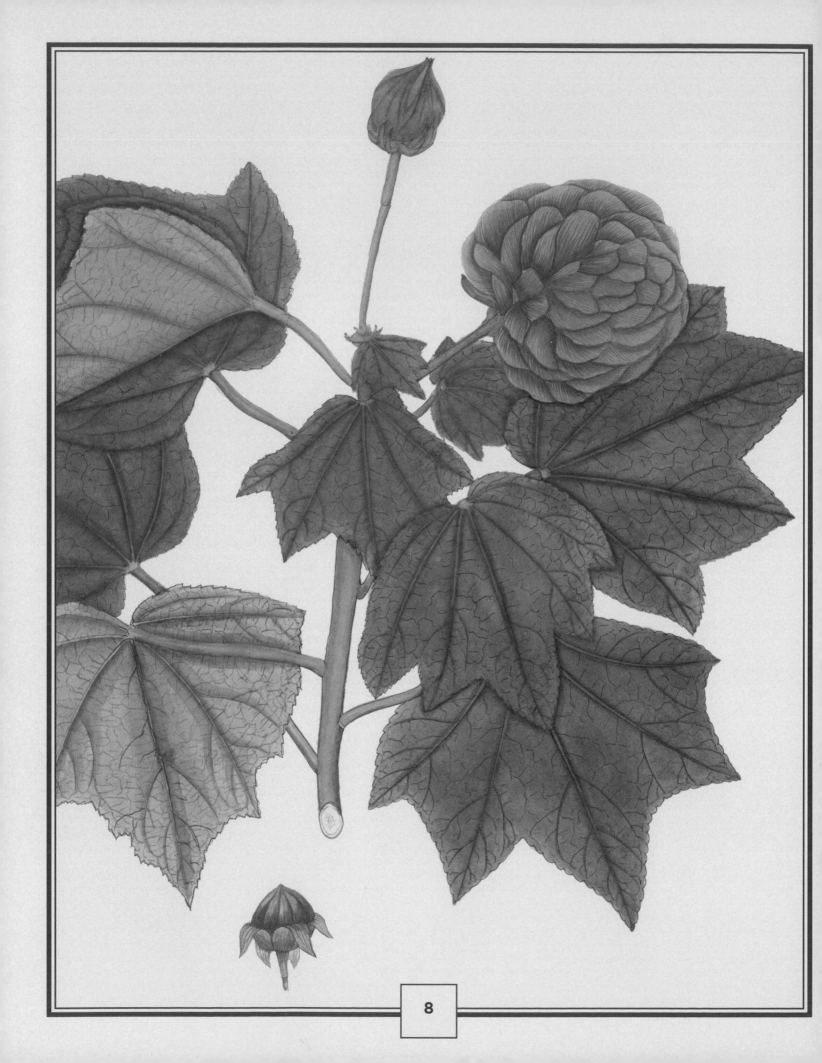

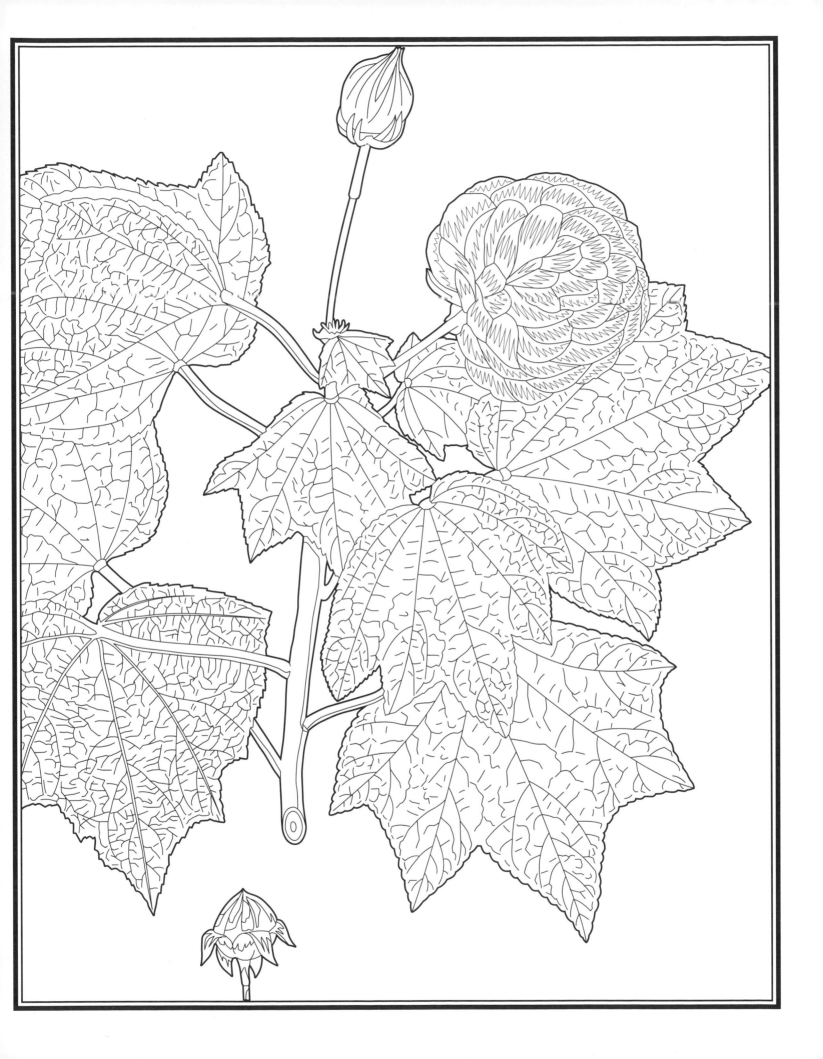

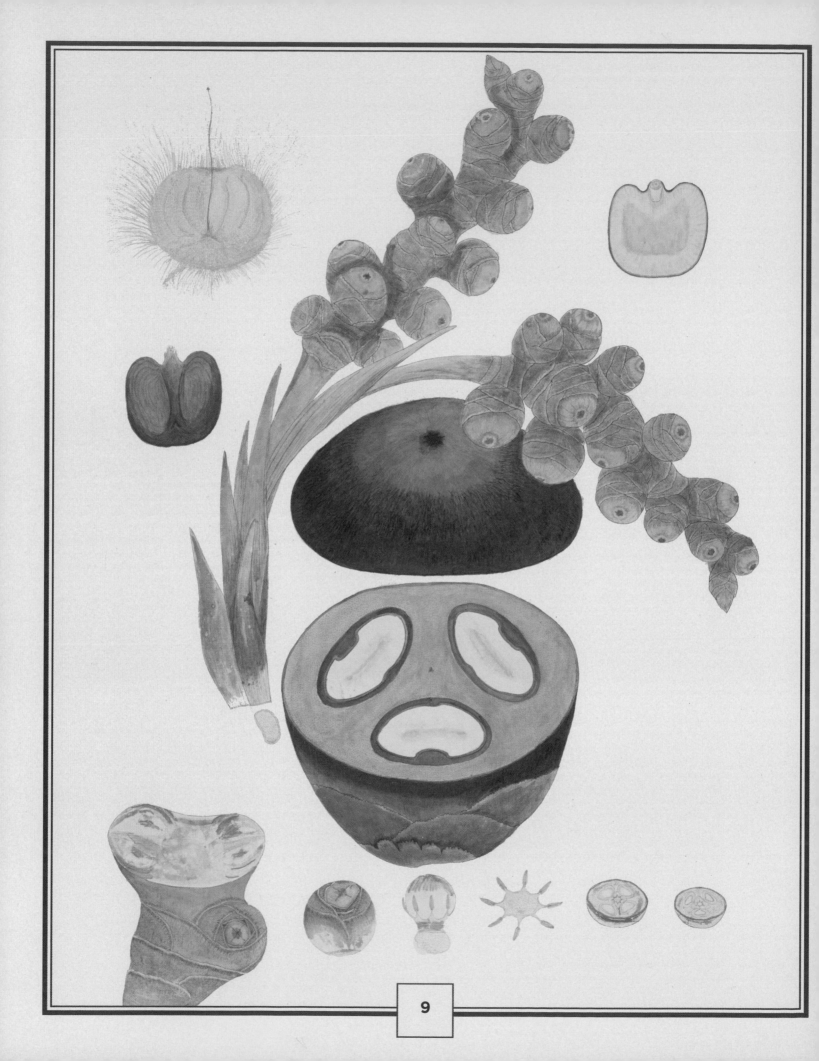

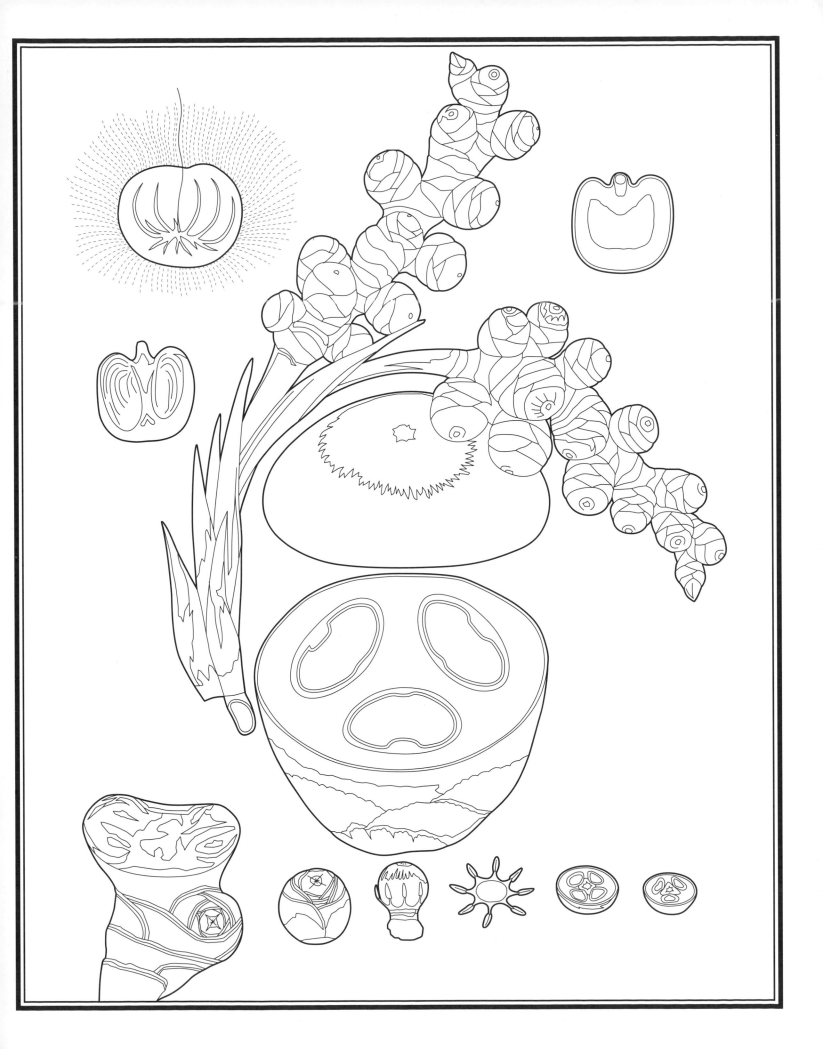

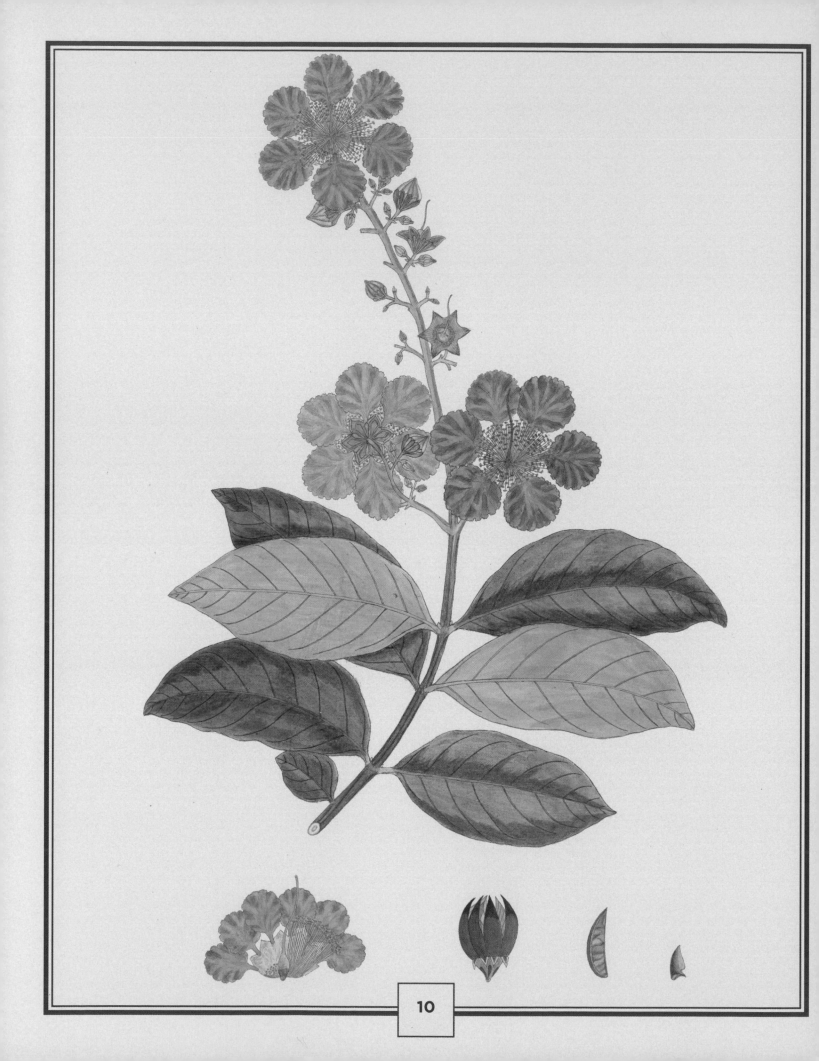

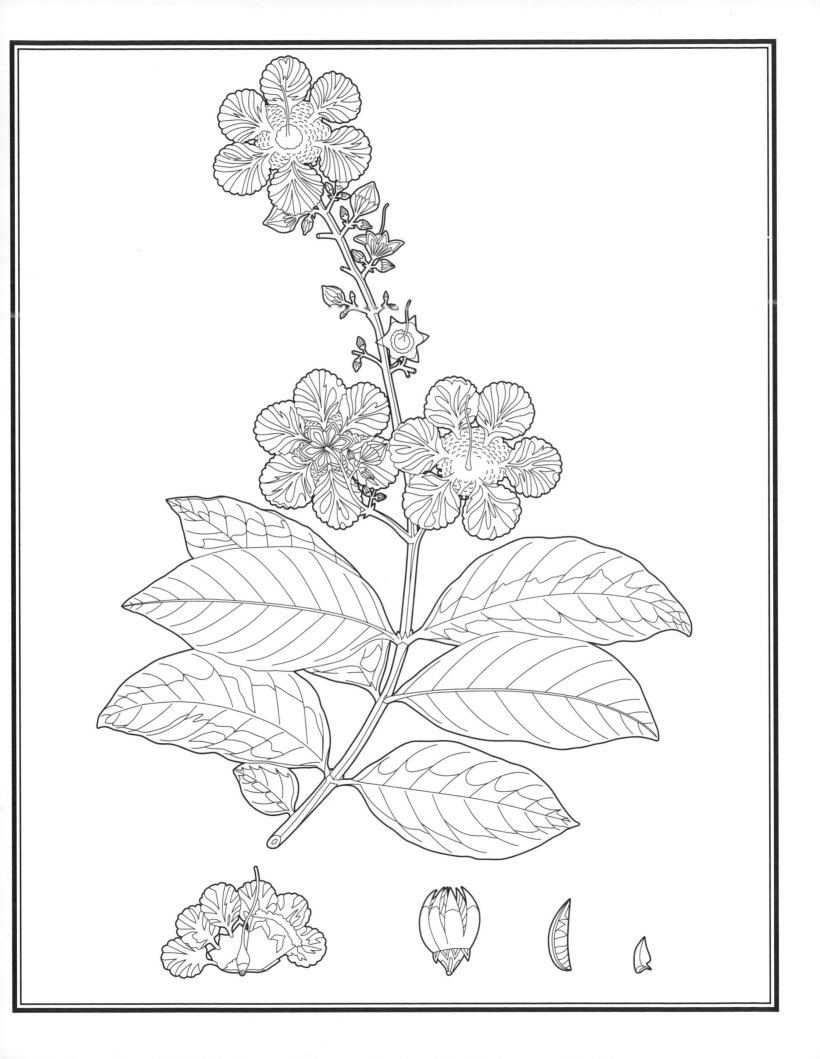

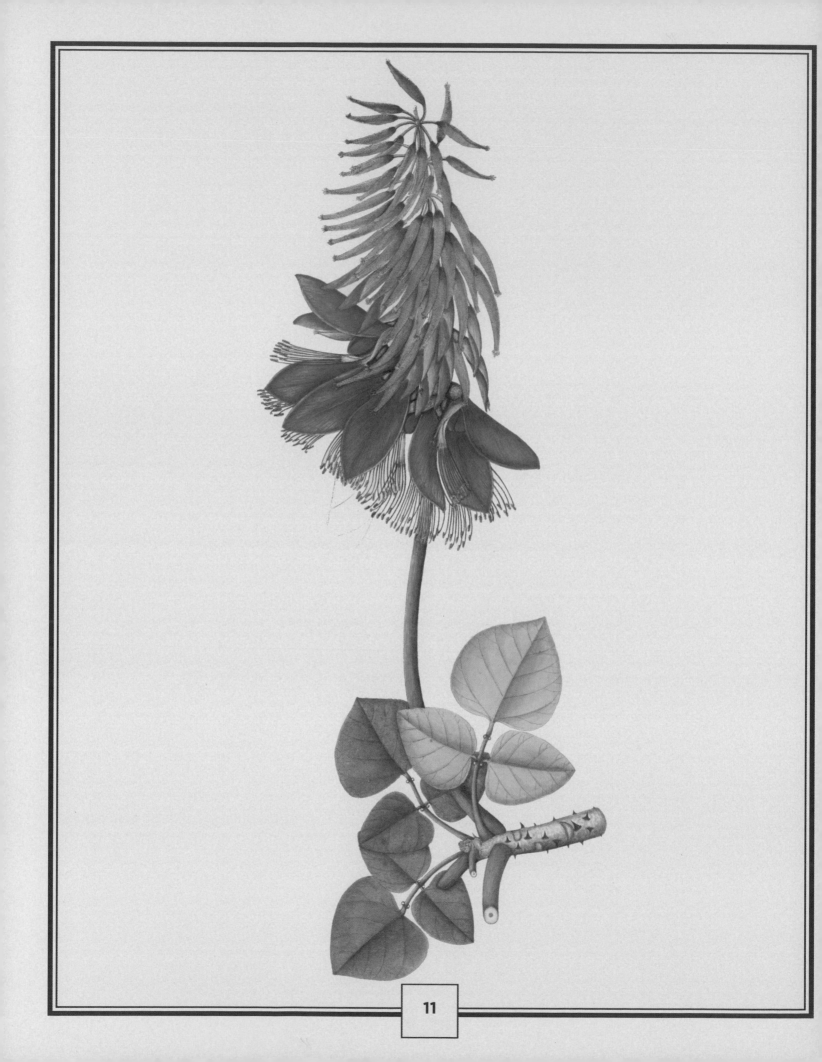

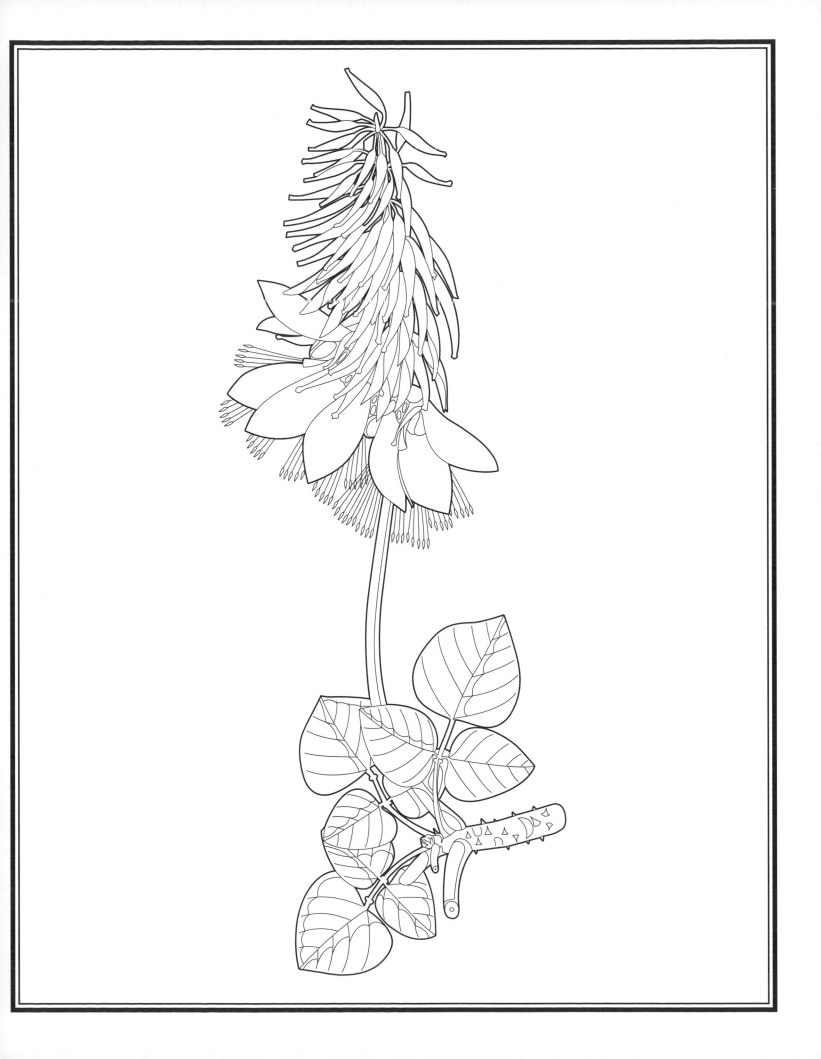

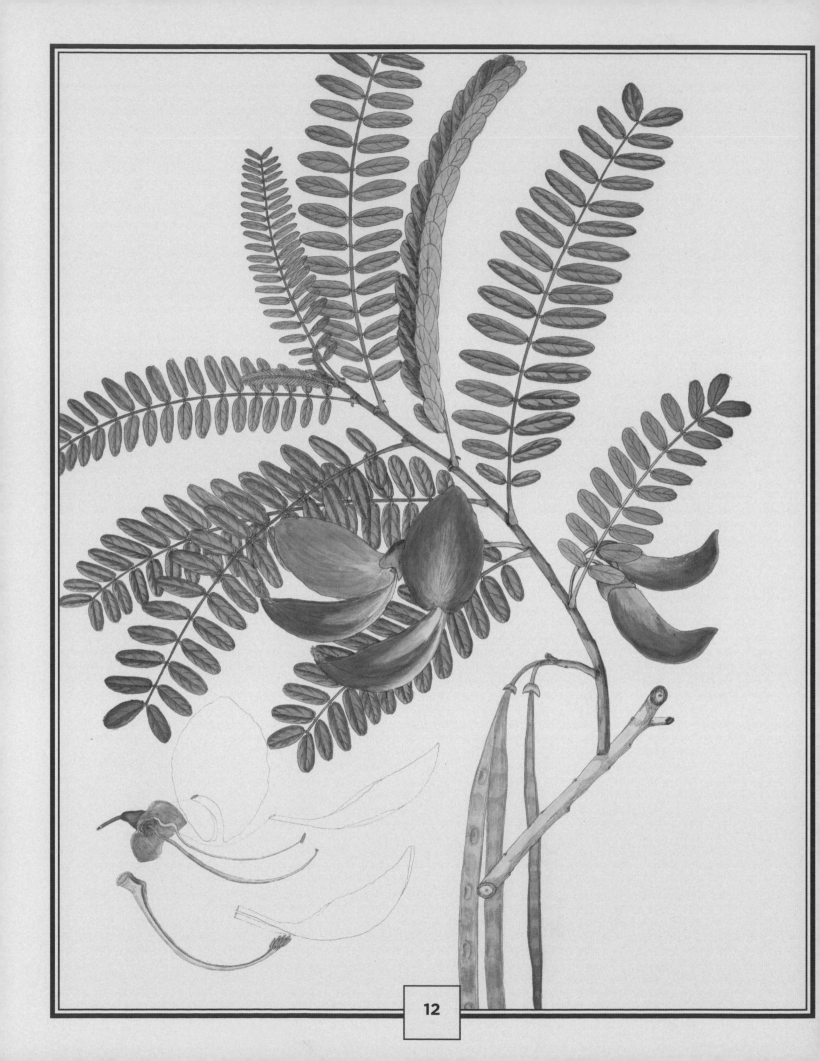

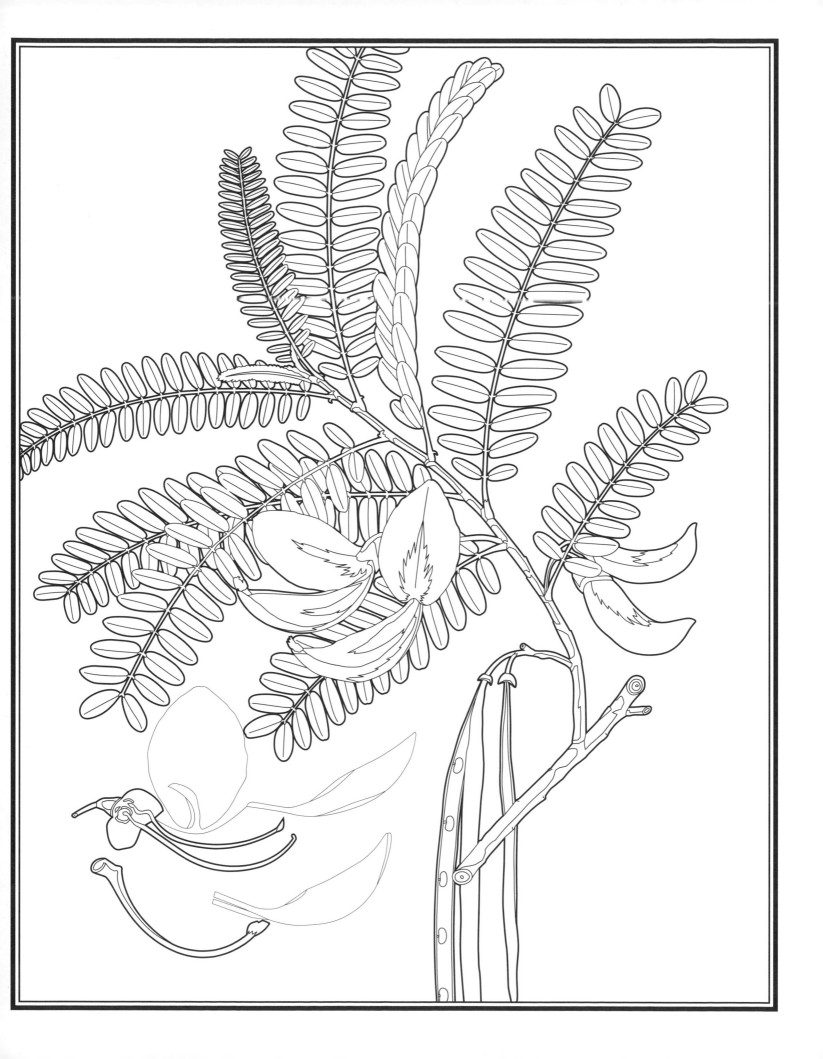

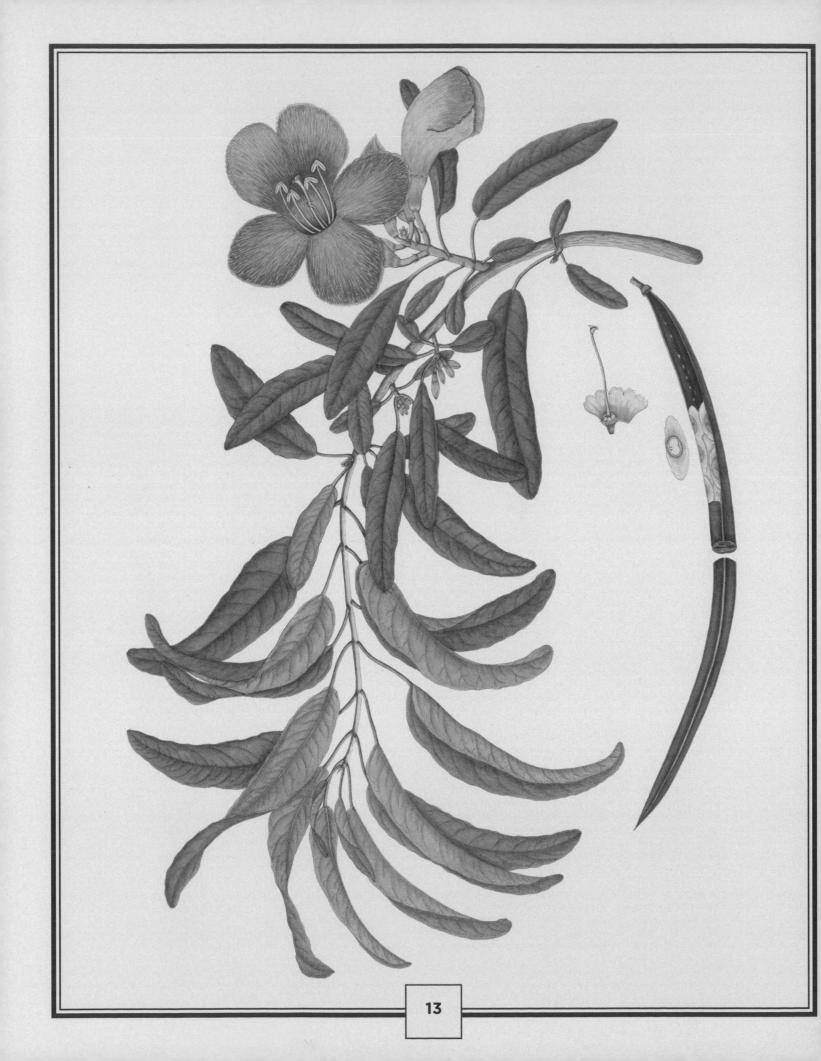

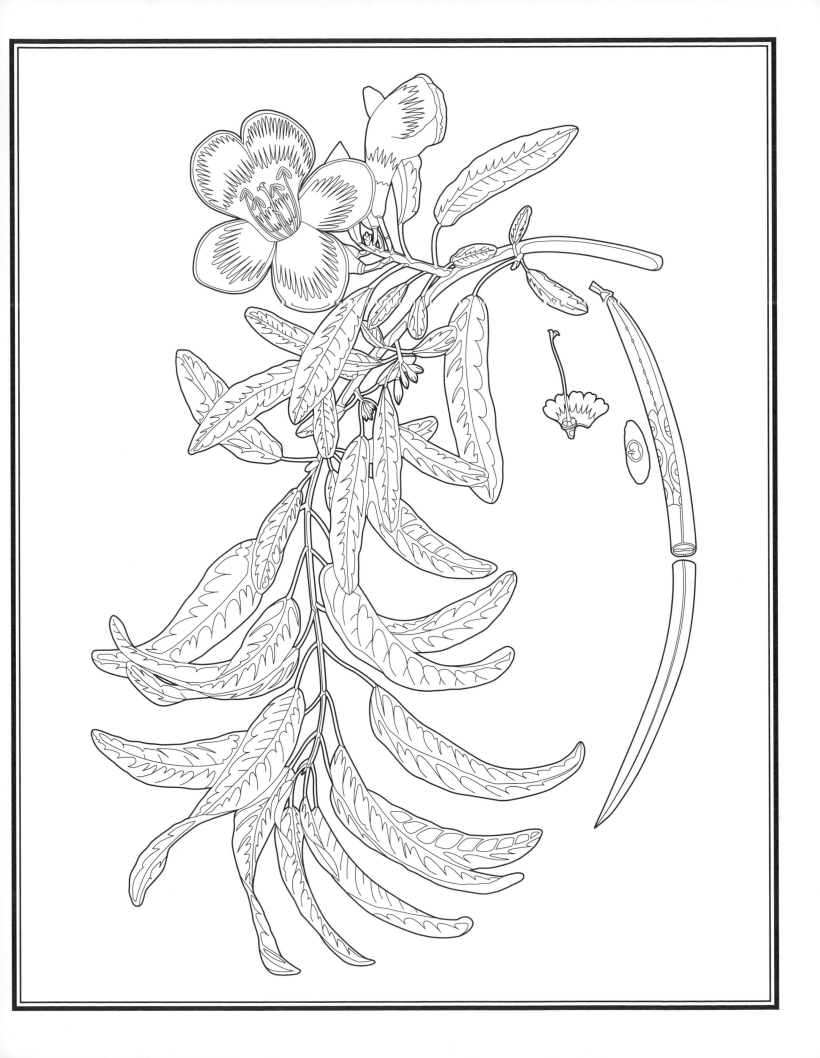

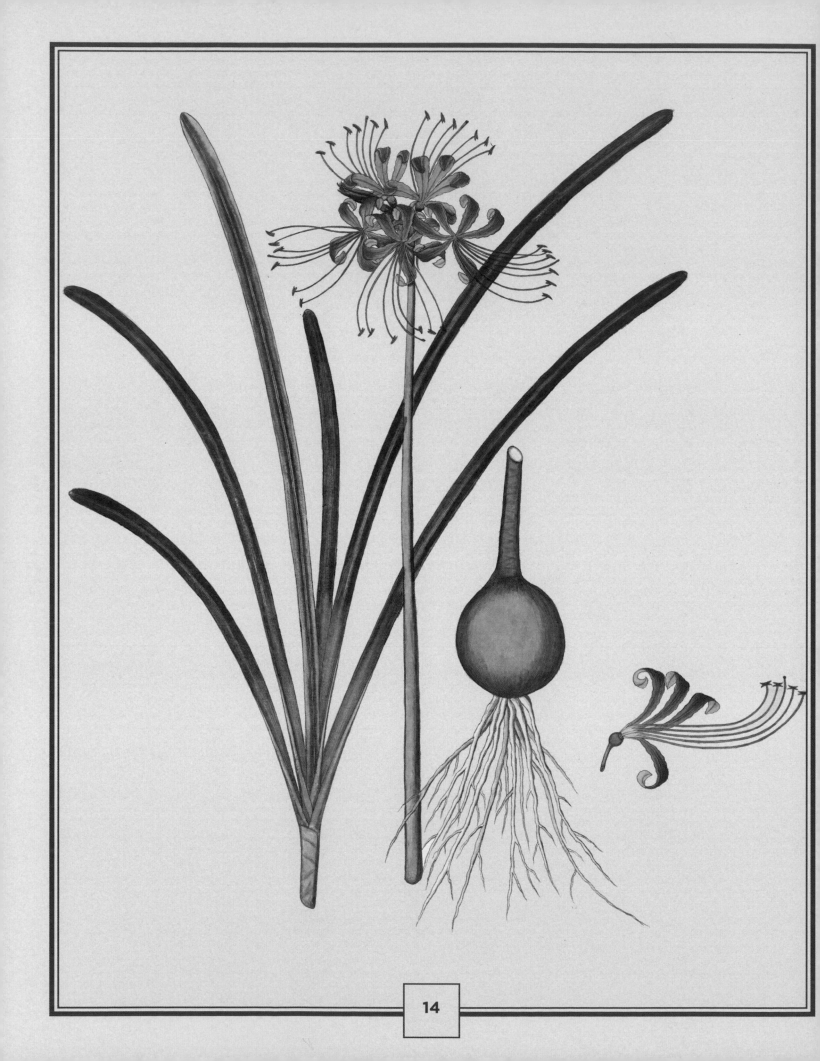

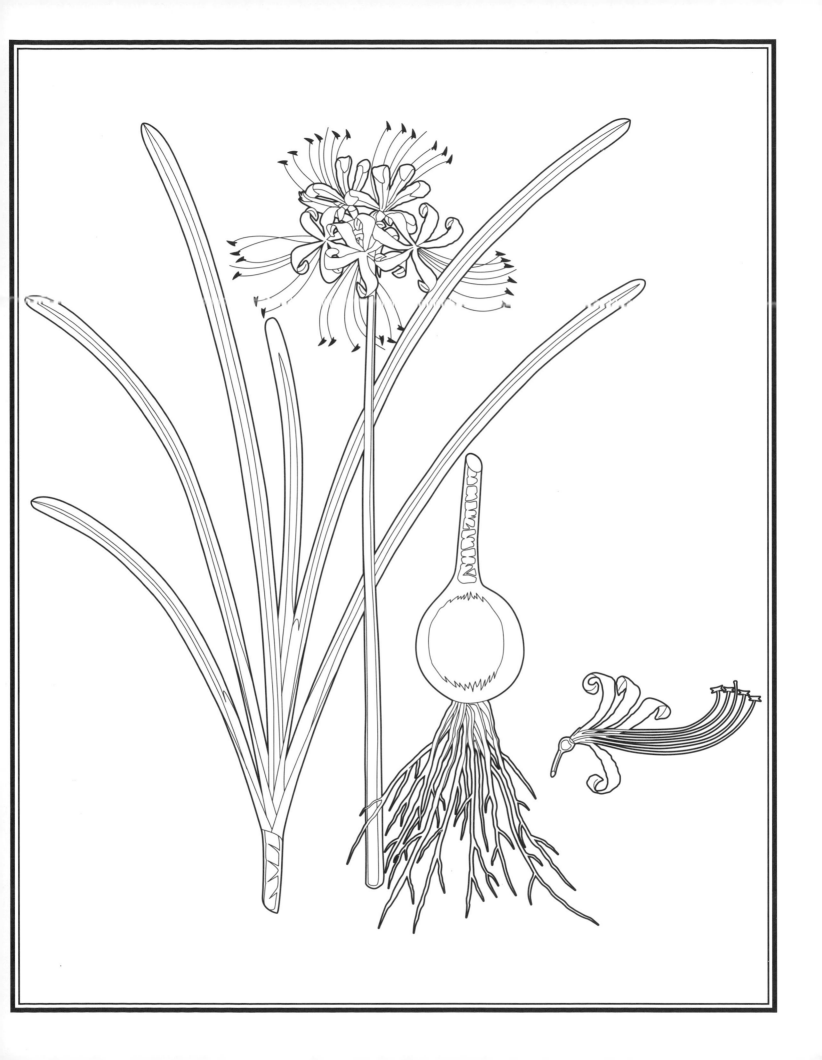

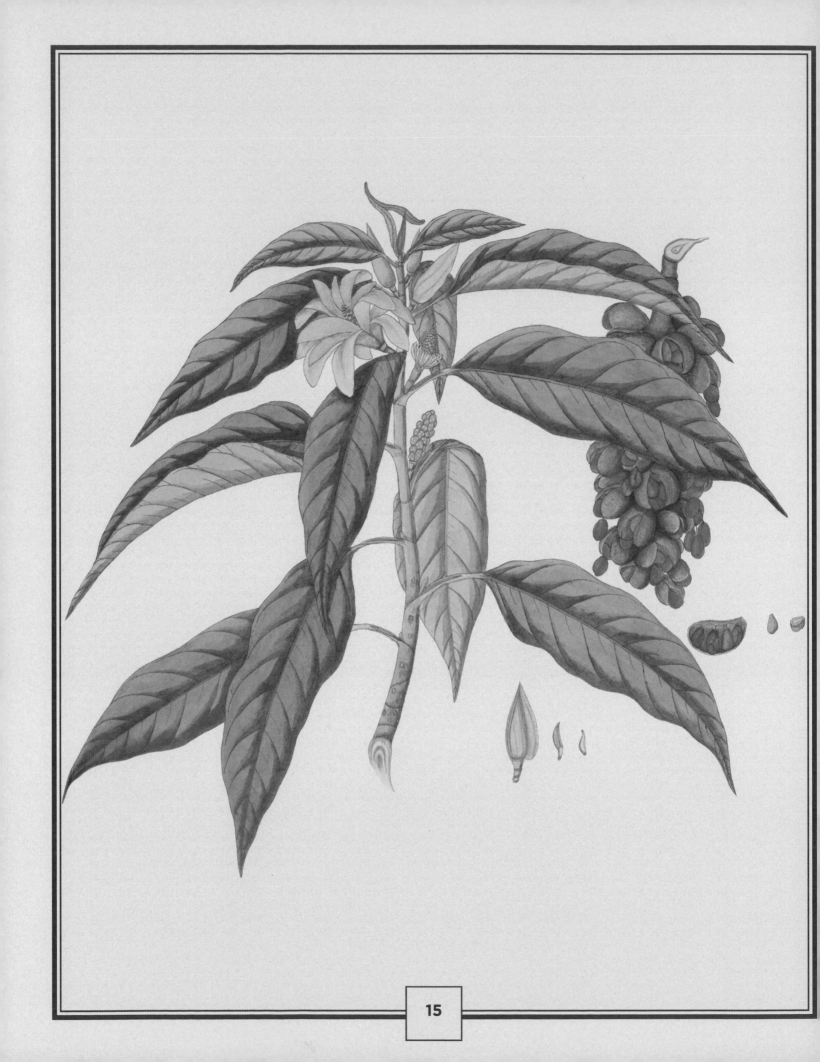

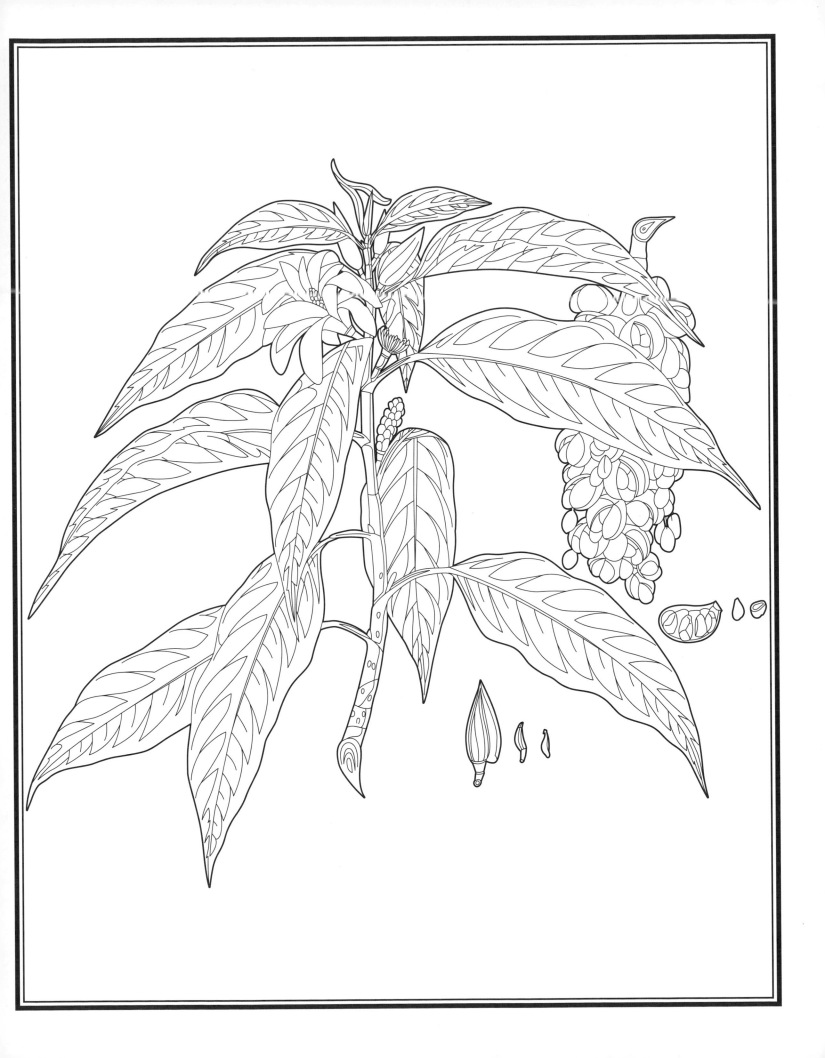

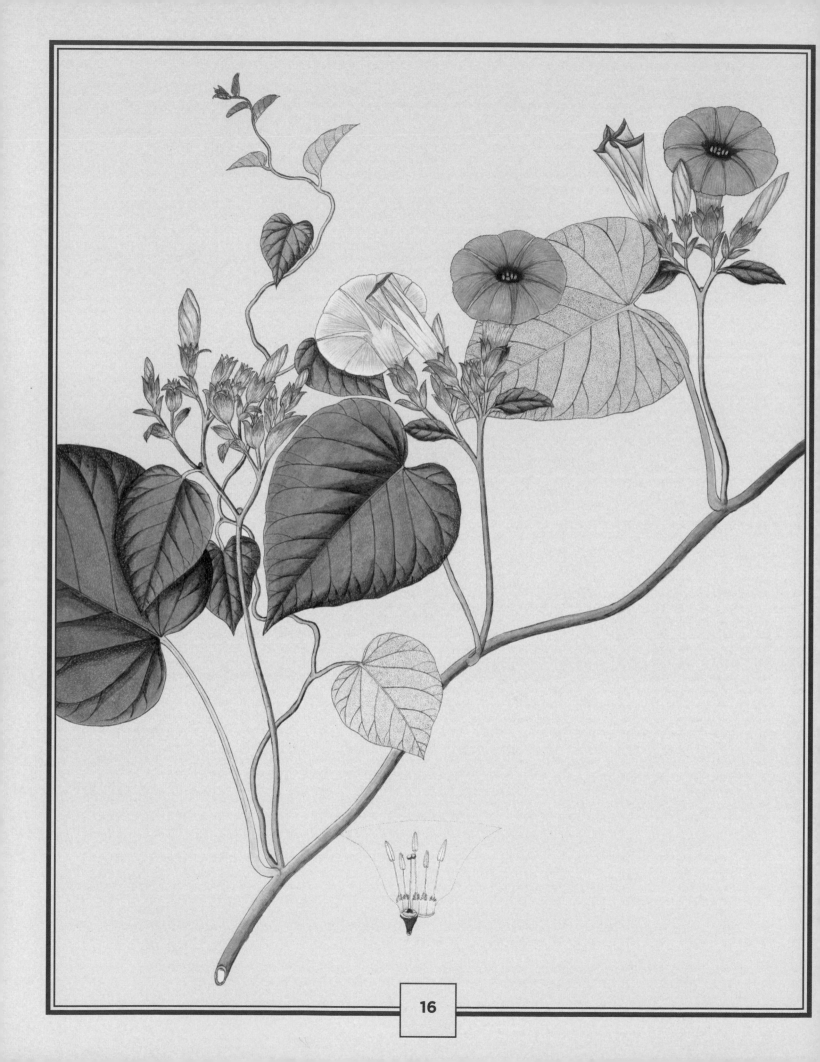

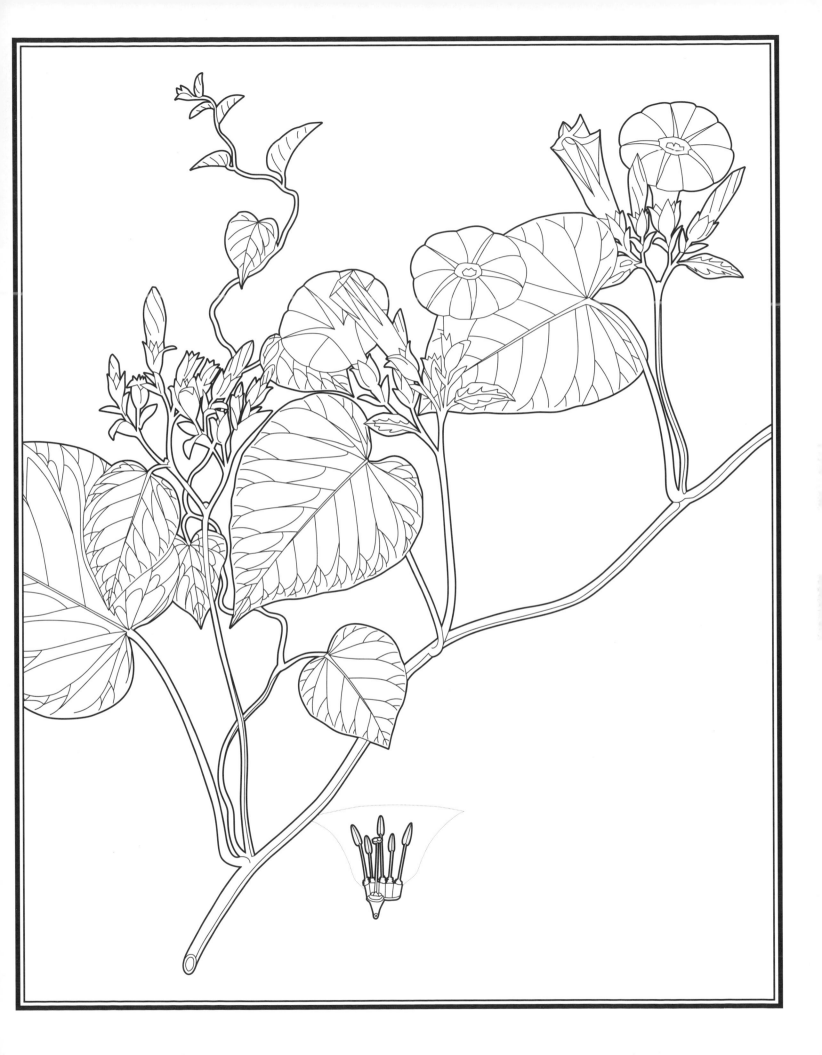

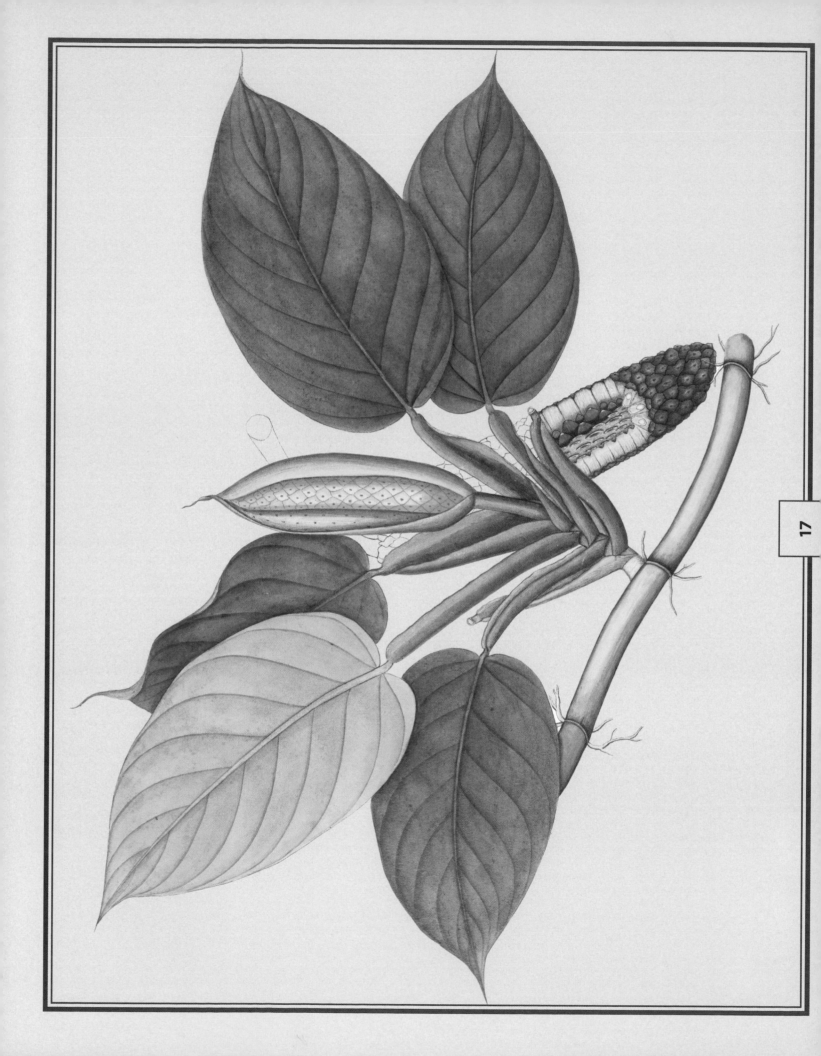

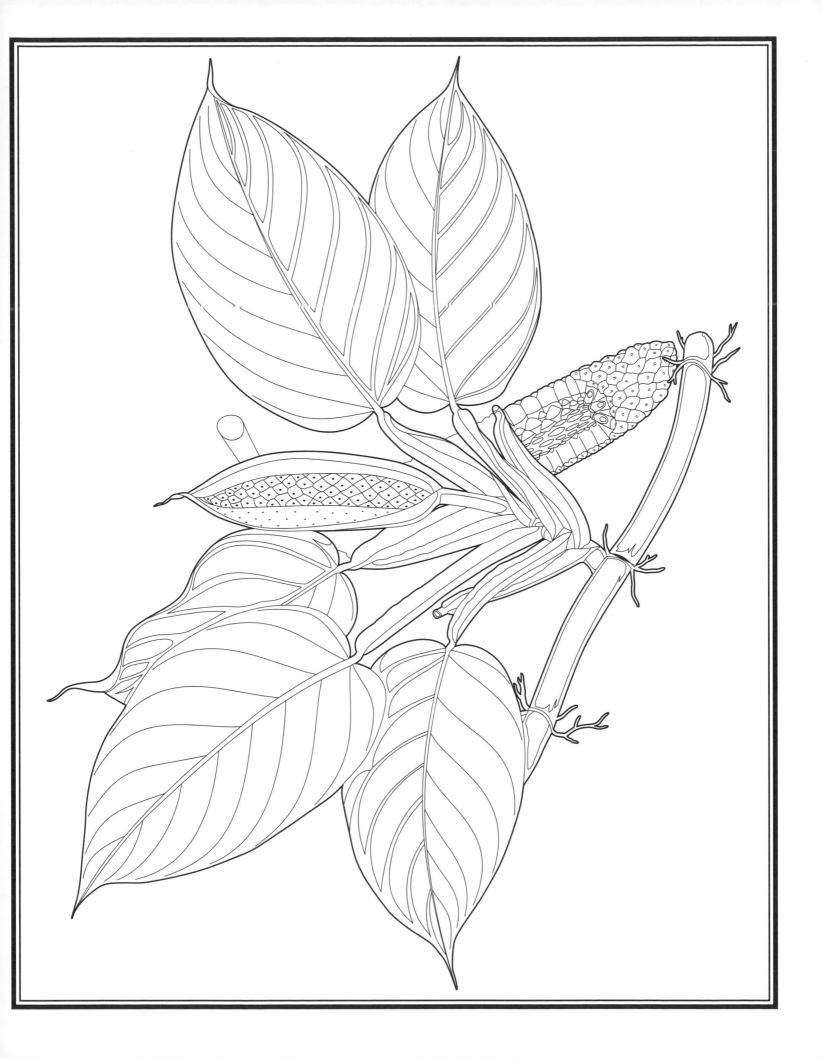

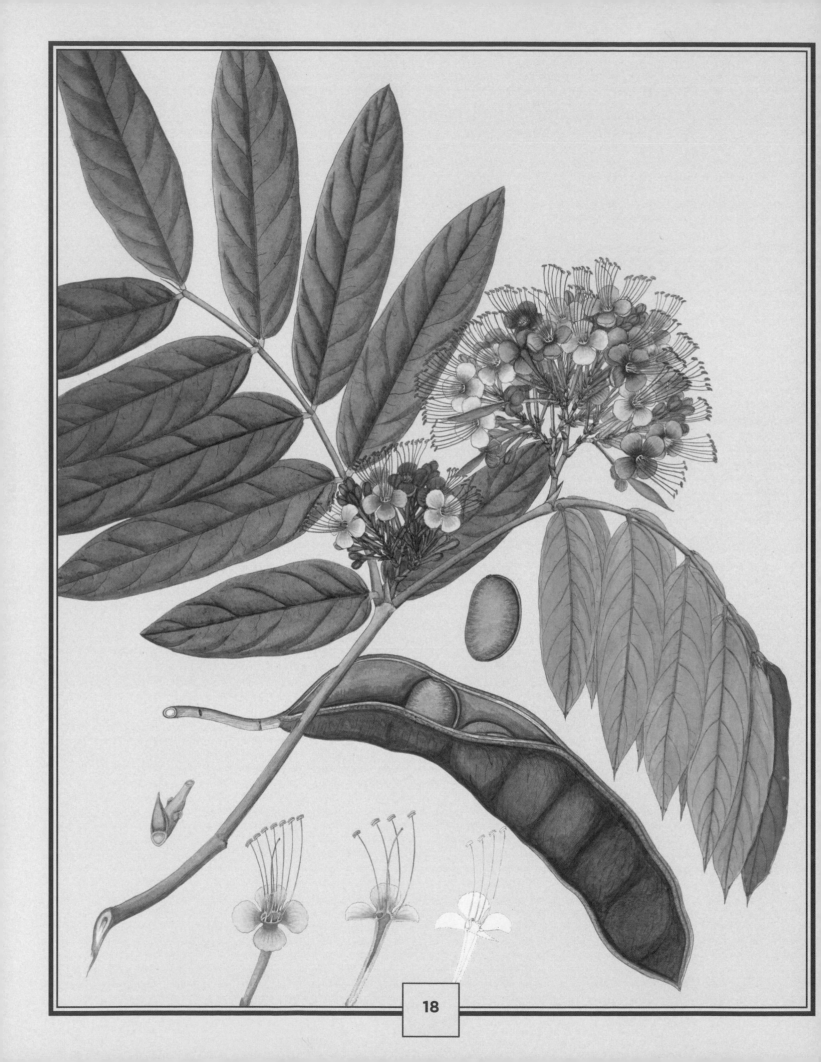

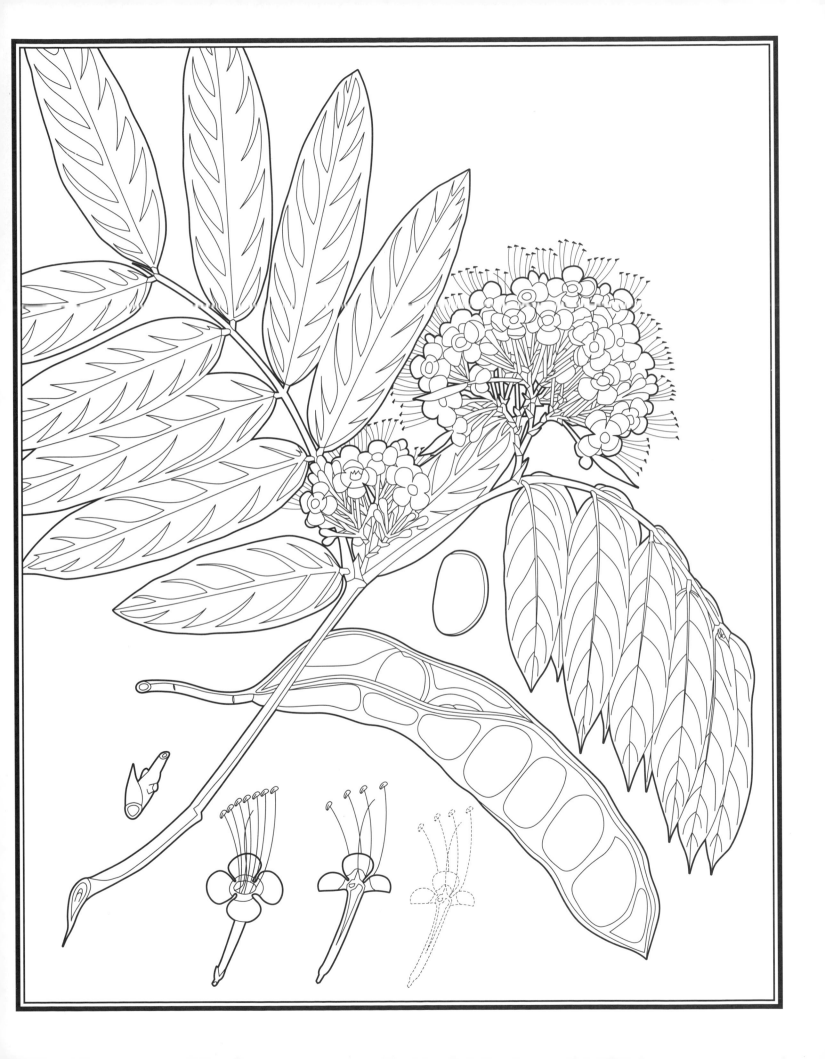

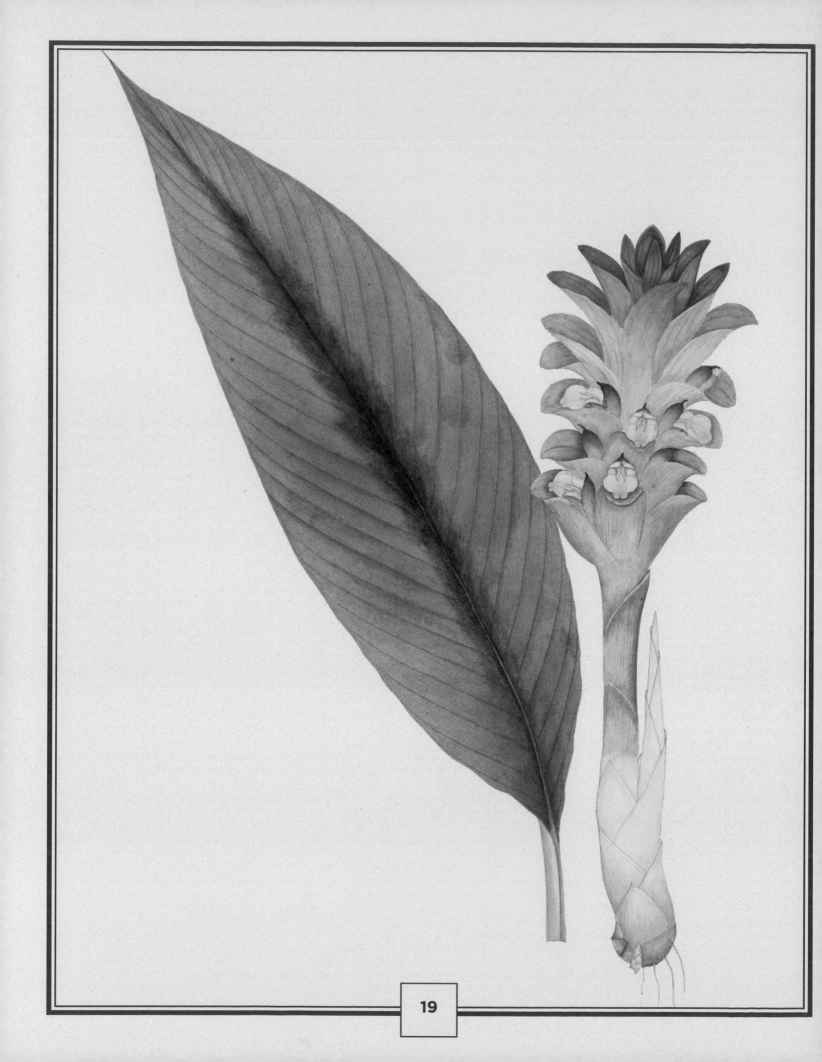

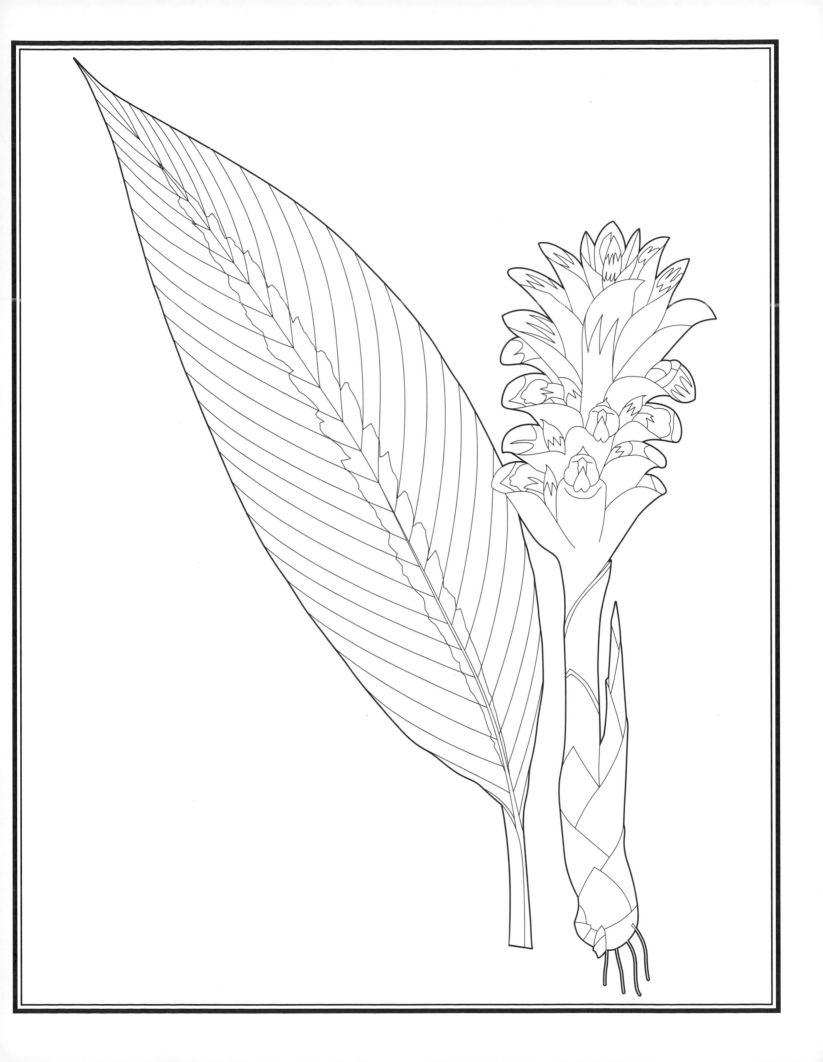

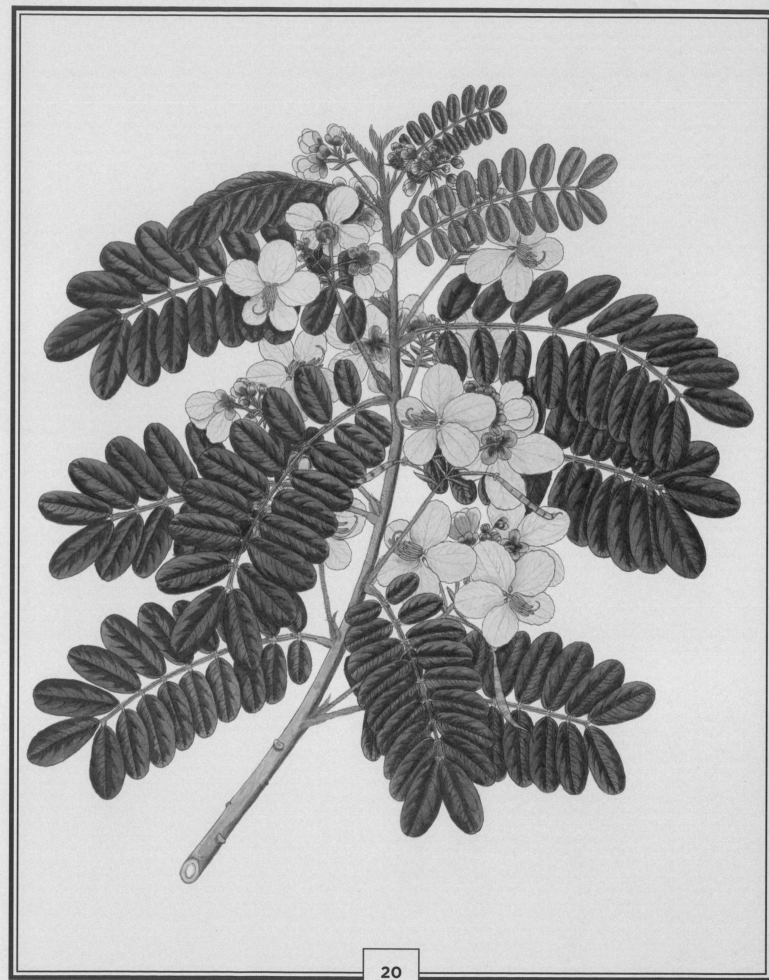

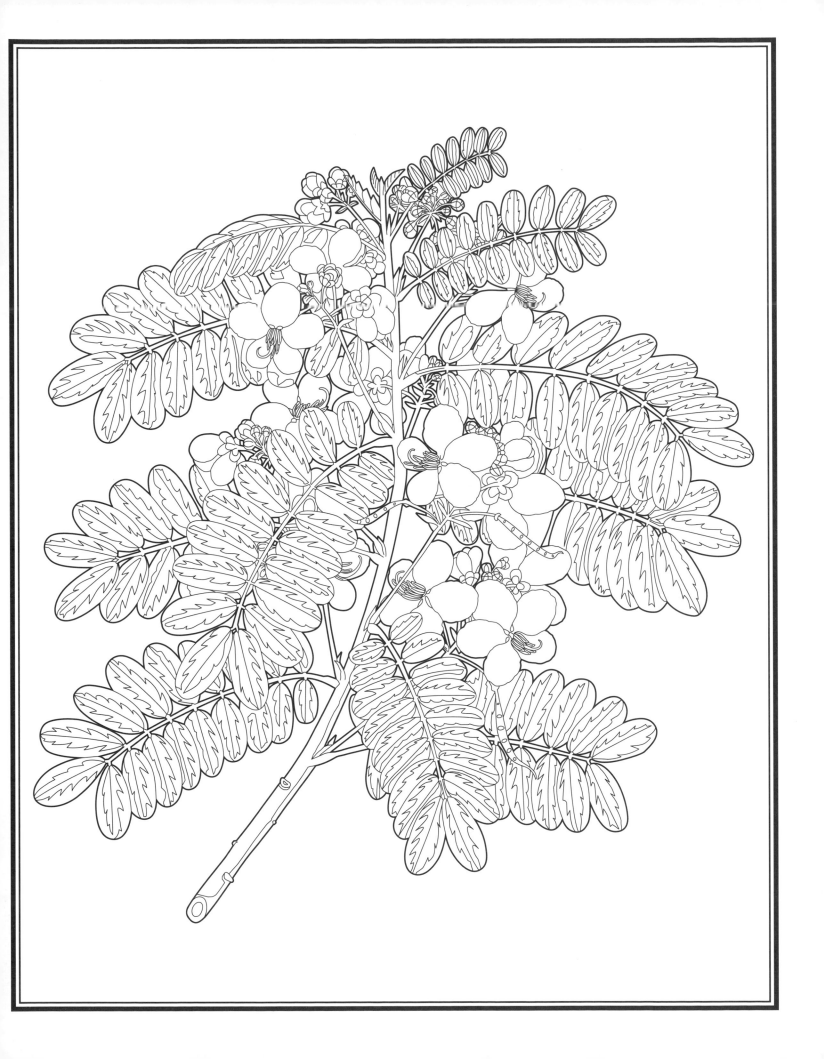

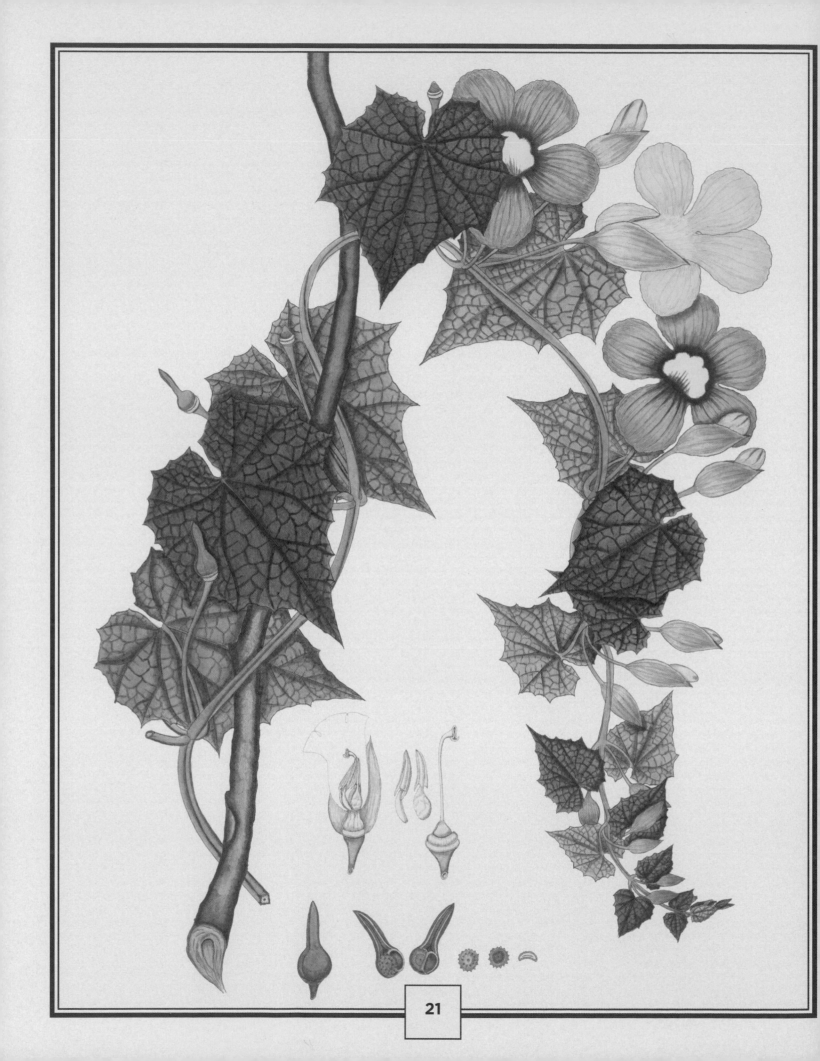

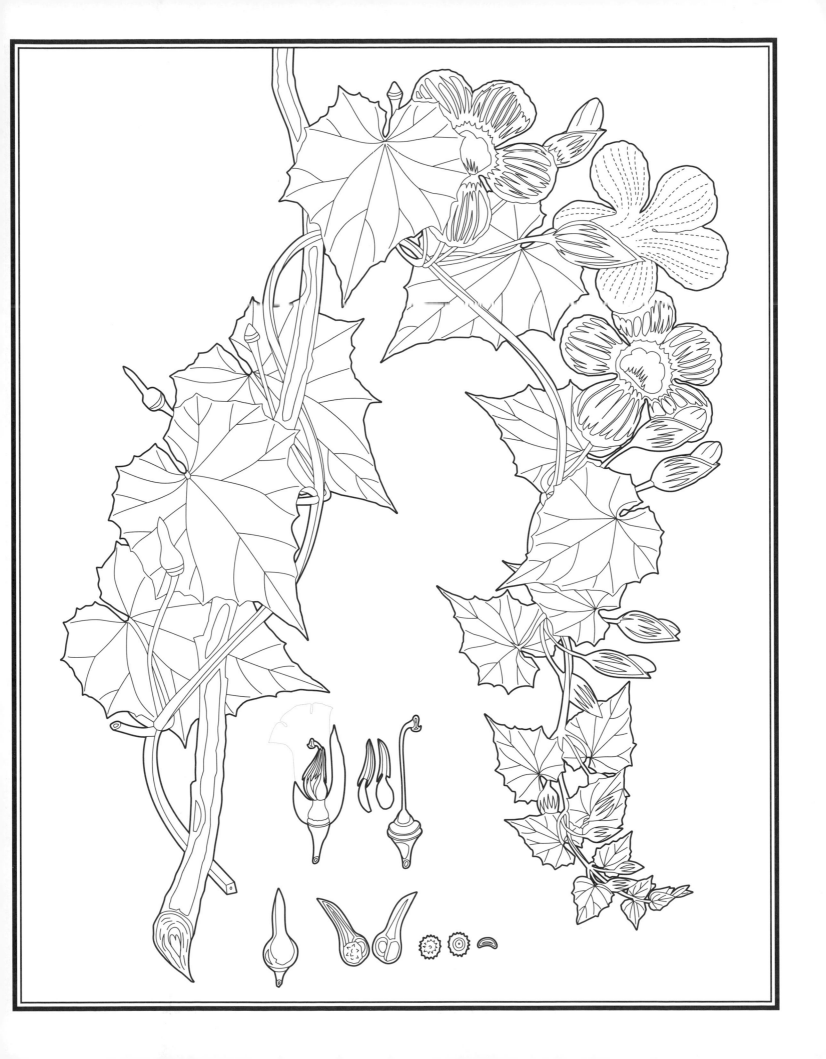

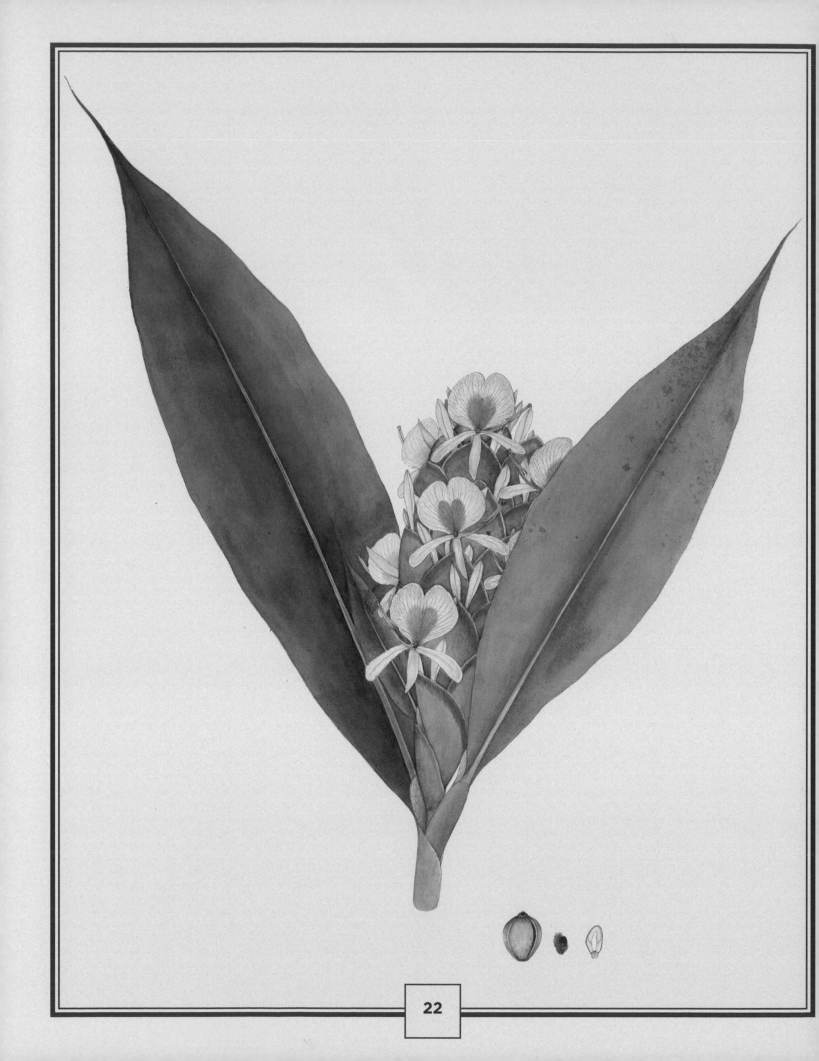

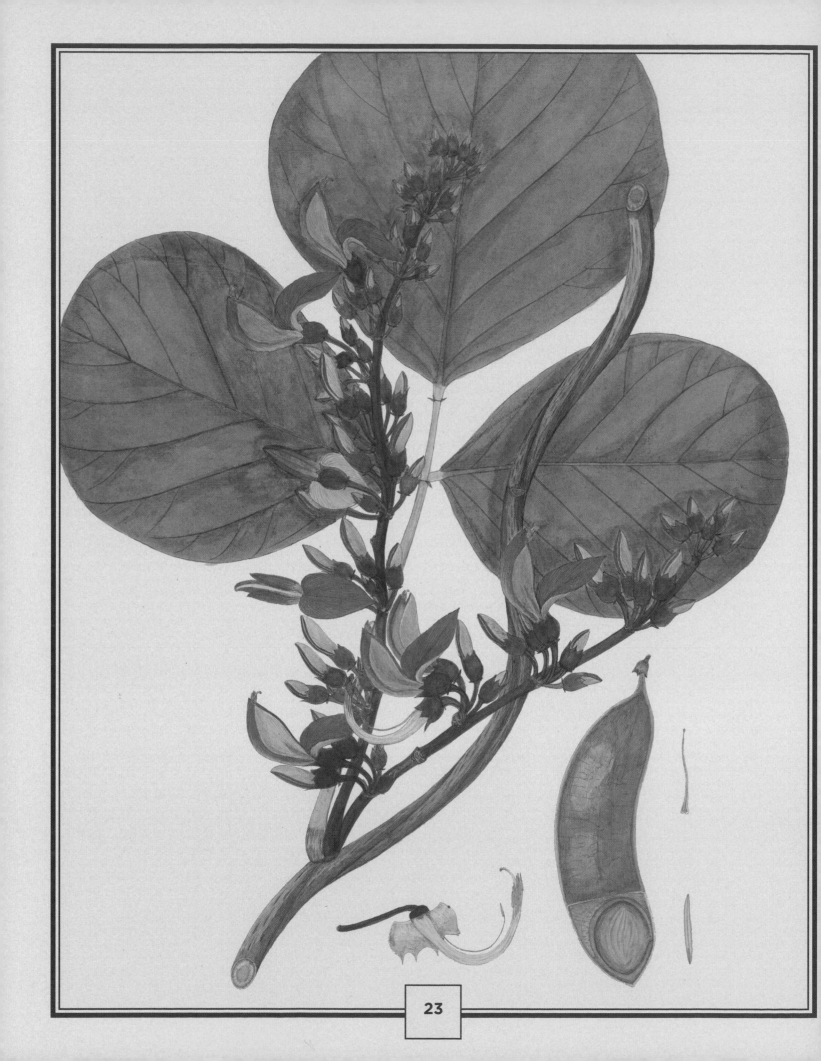

23

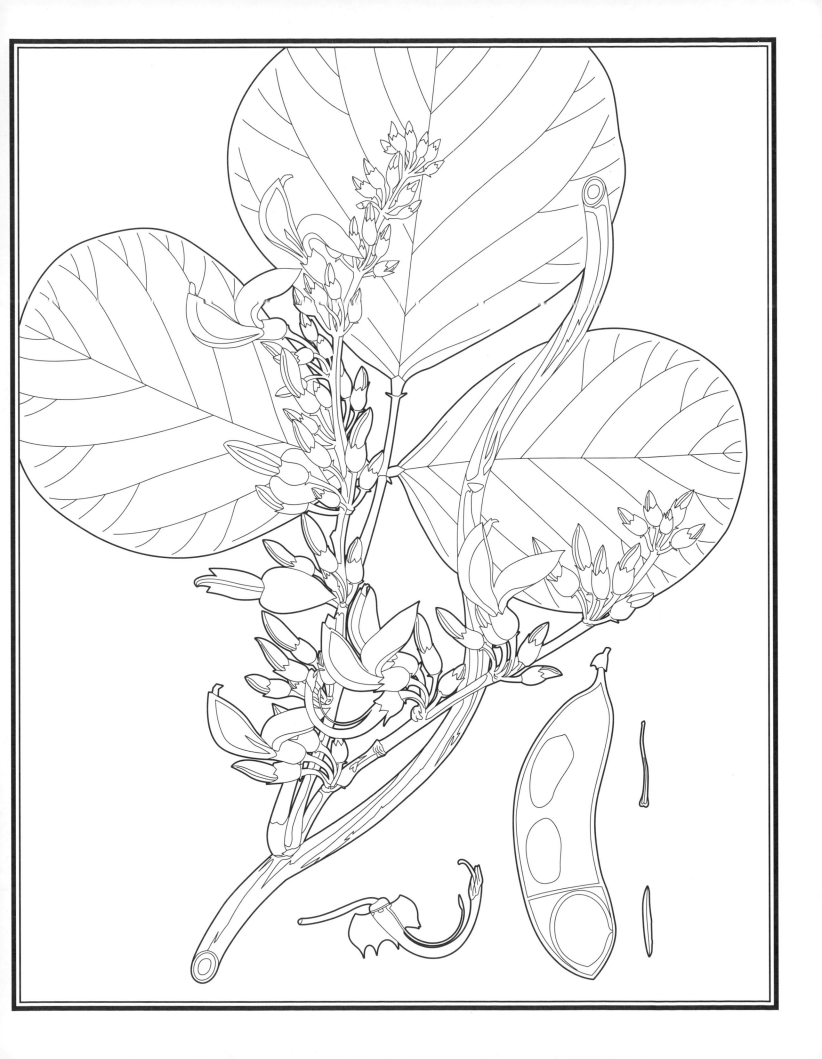

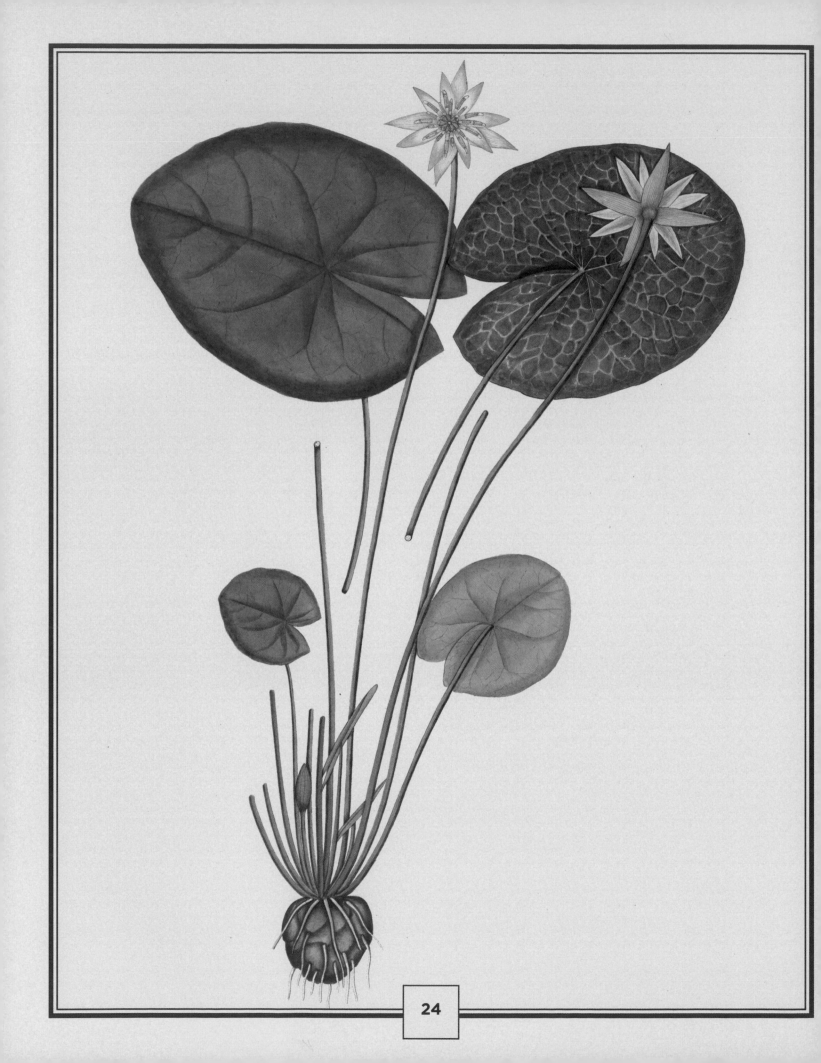

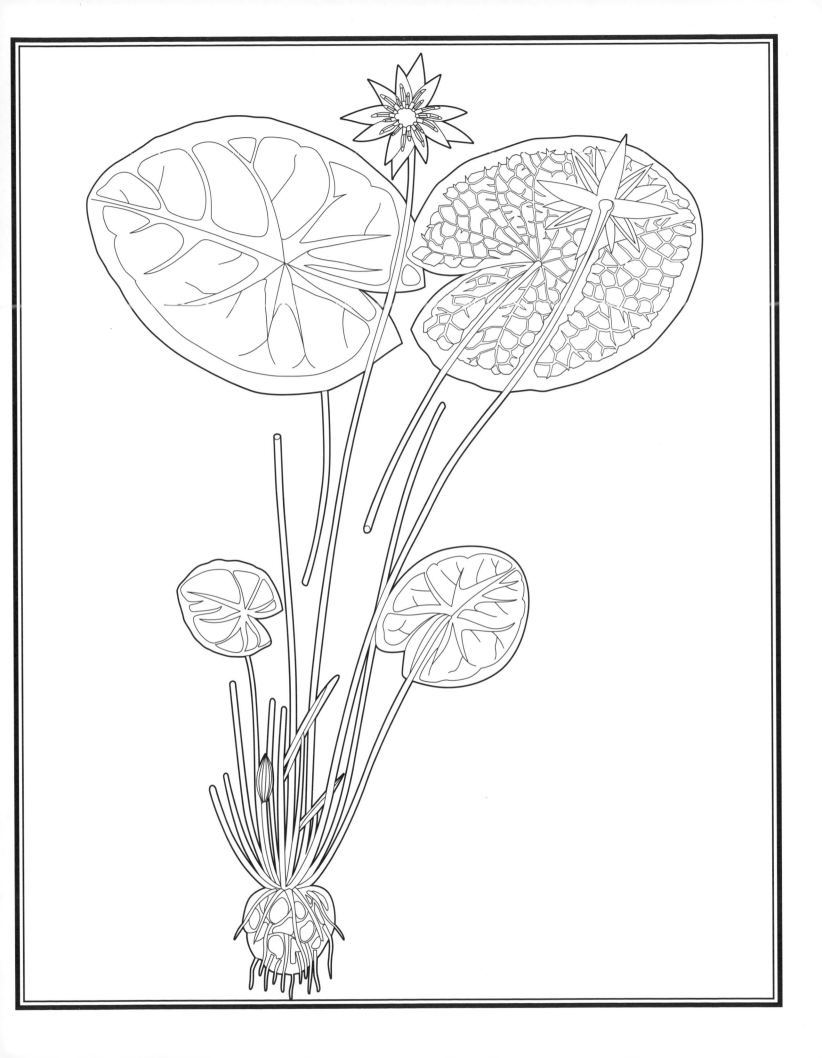

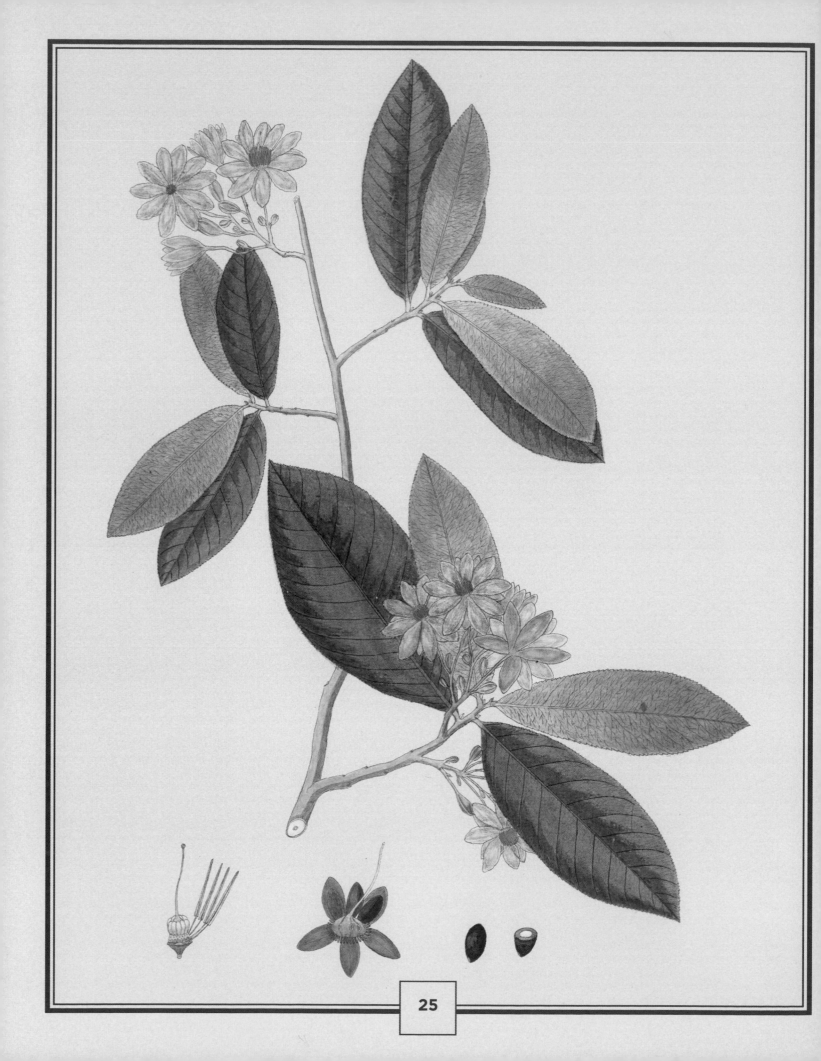

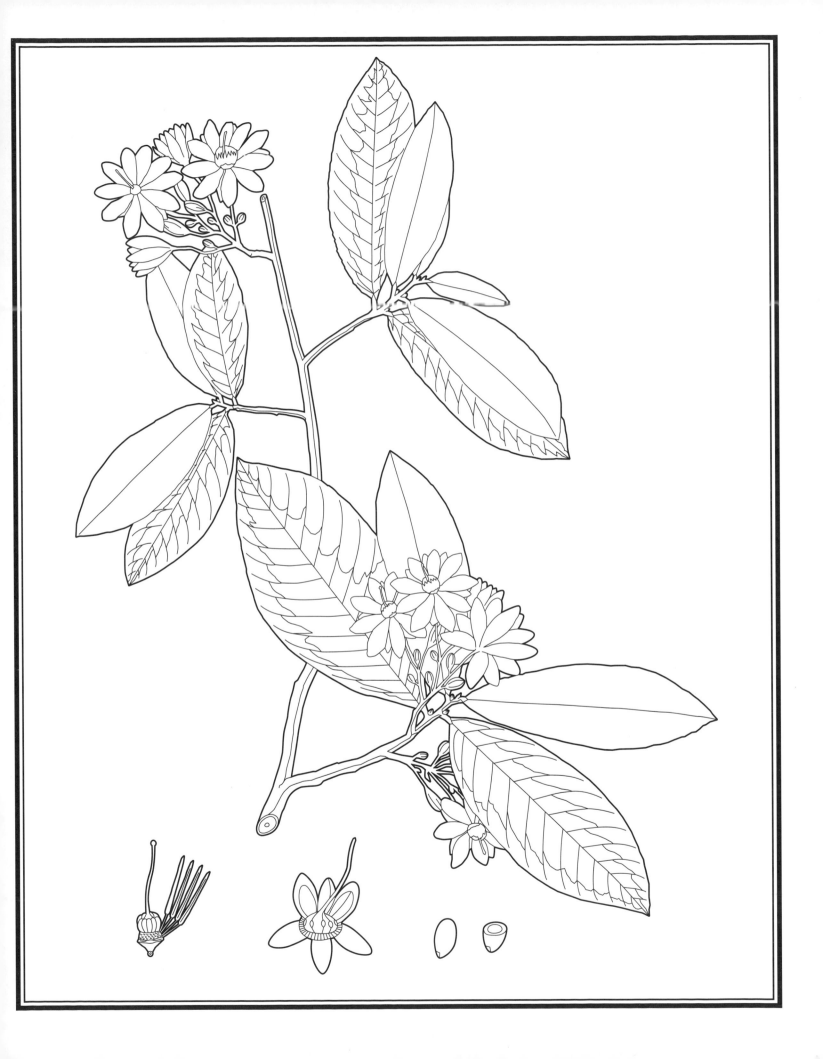

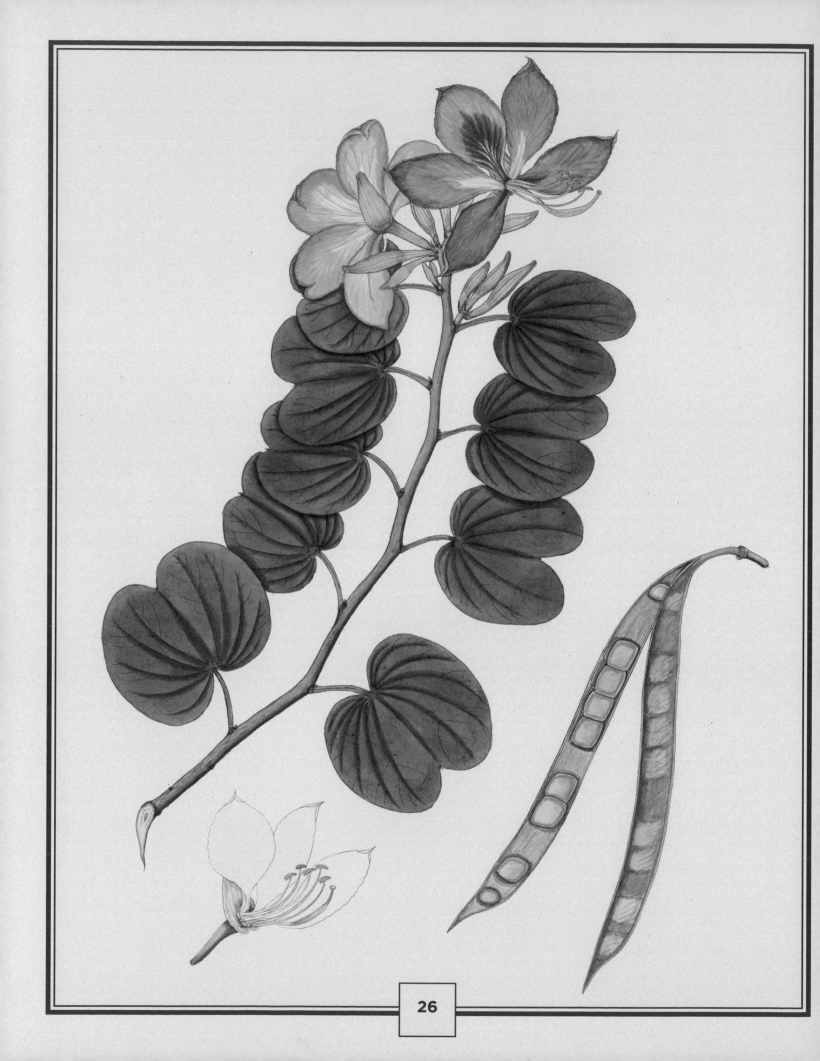

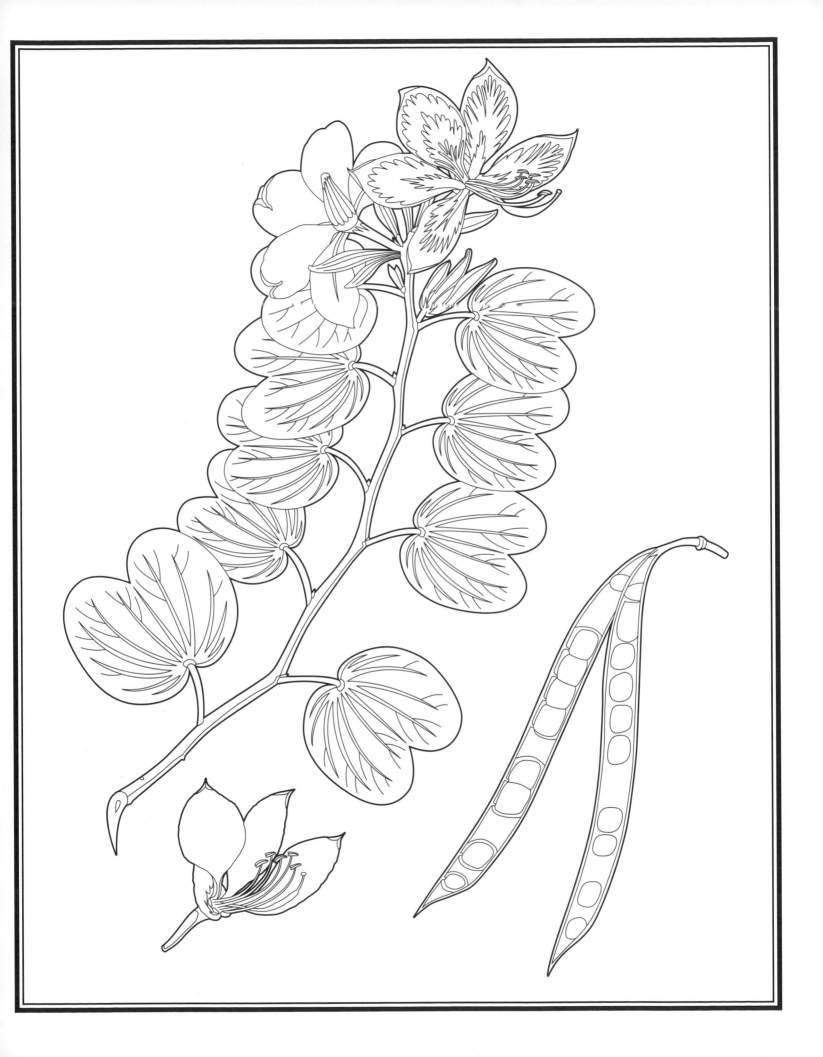

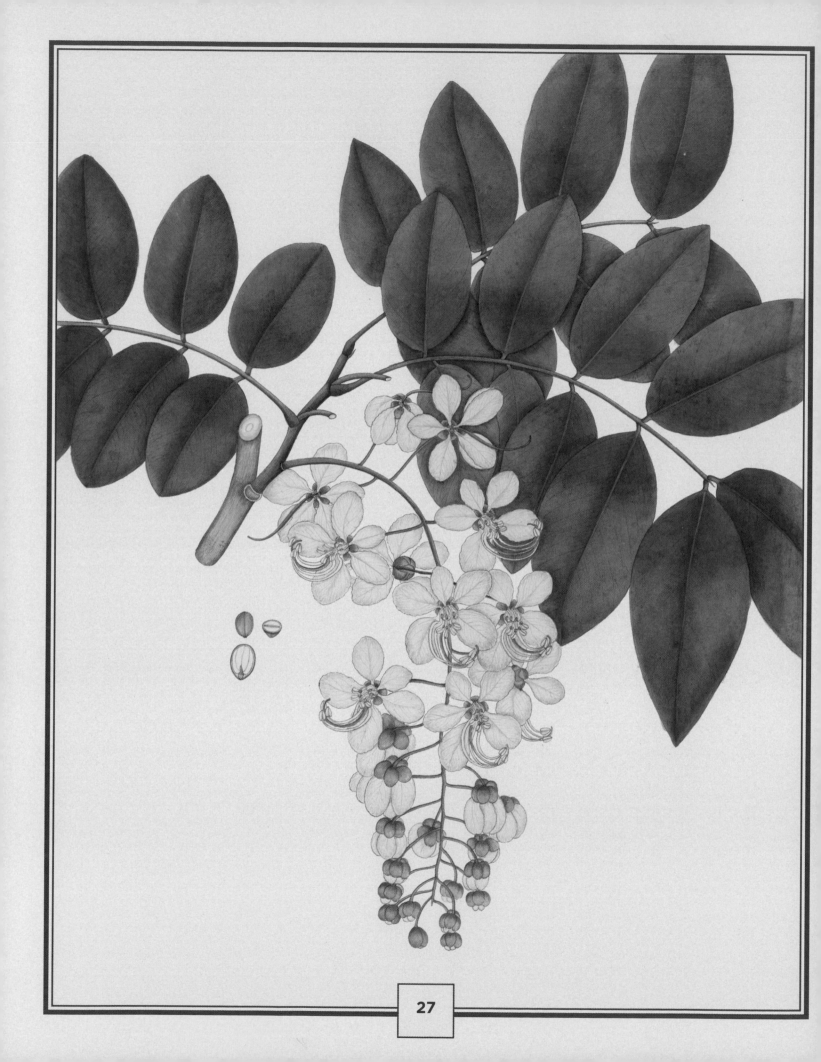

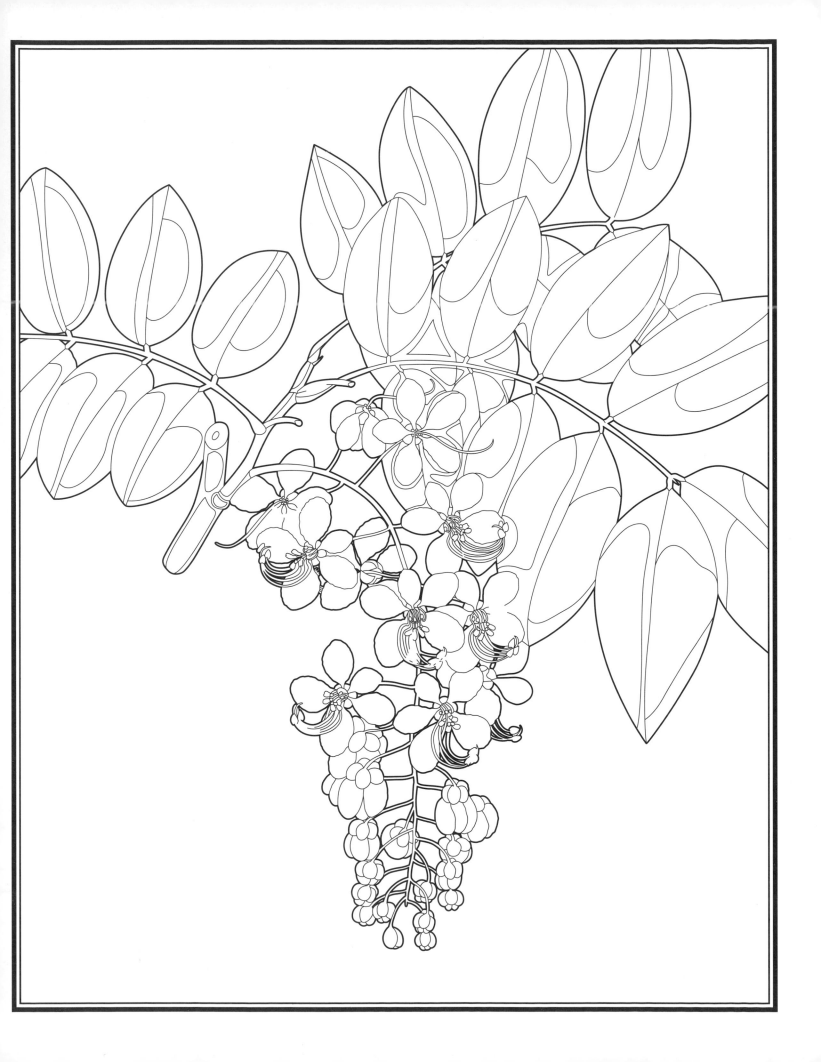

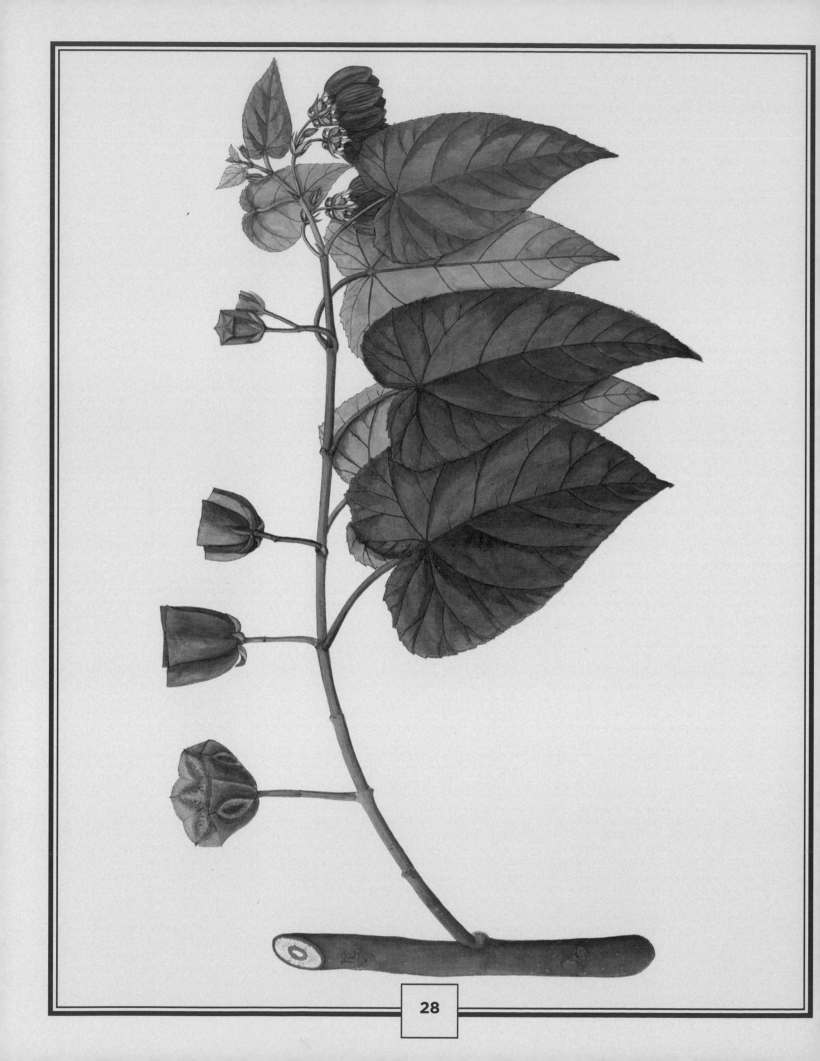

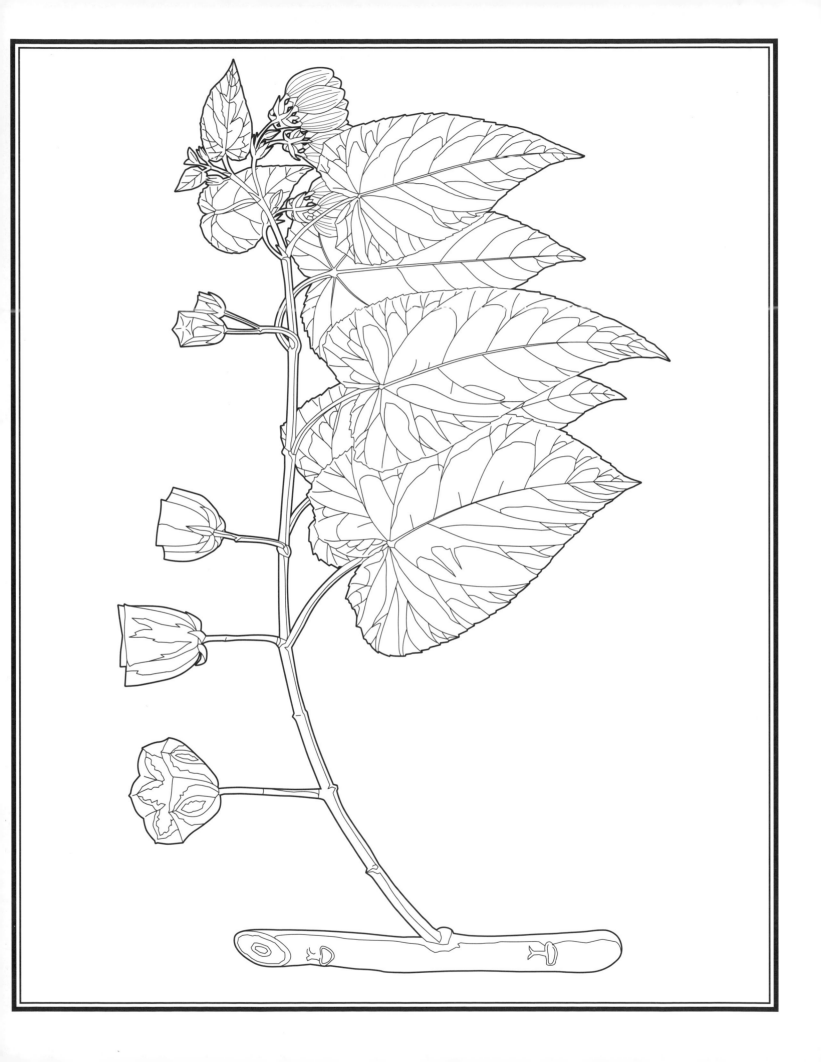

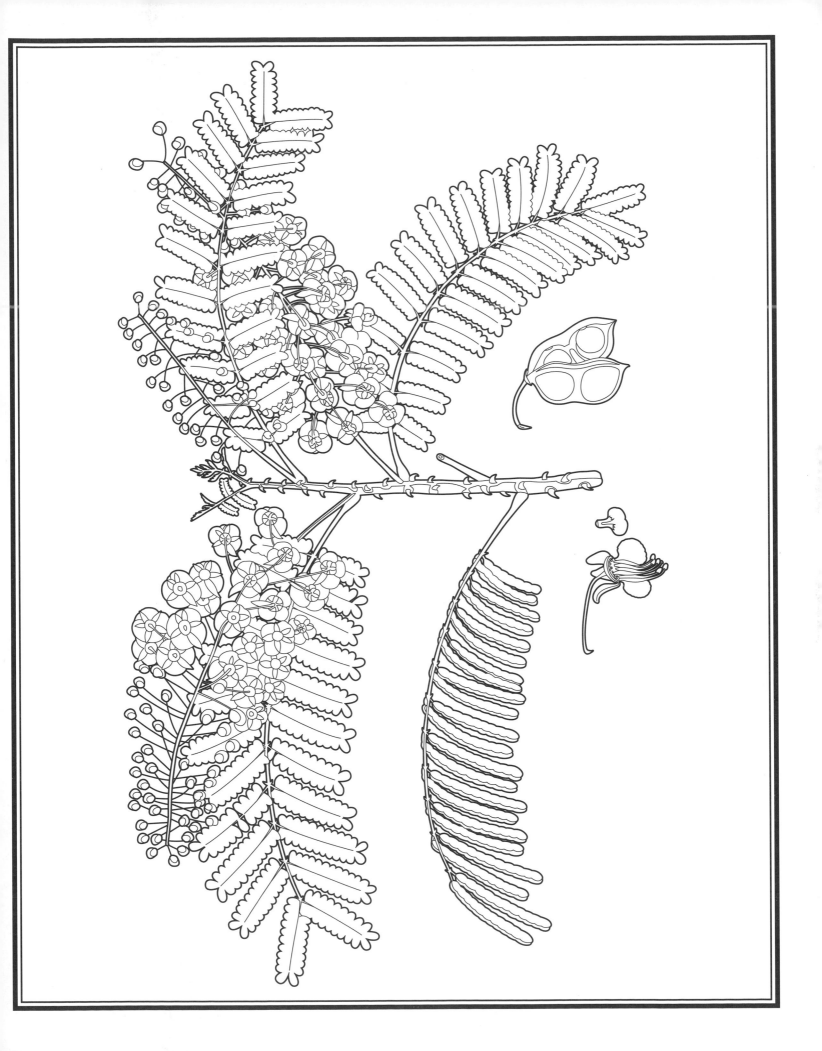

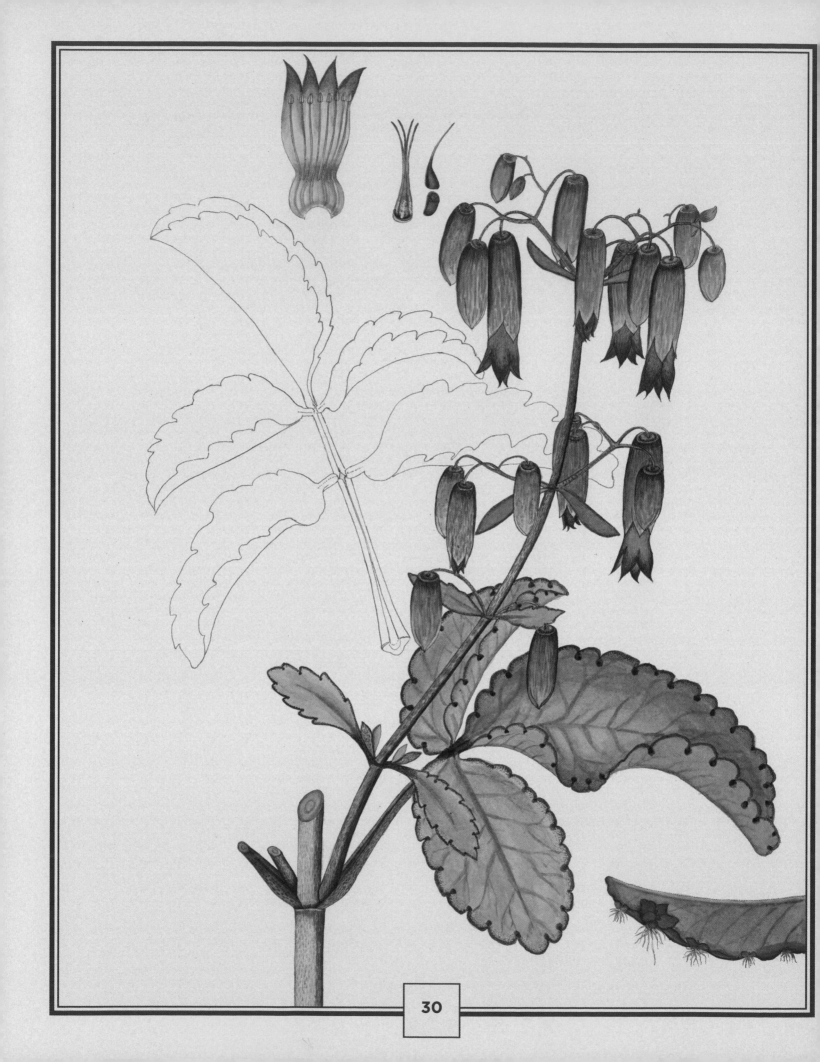

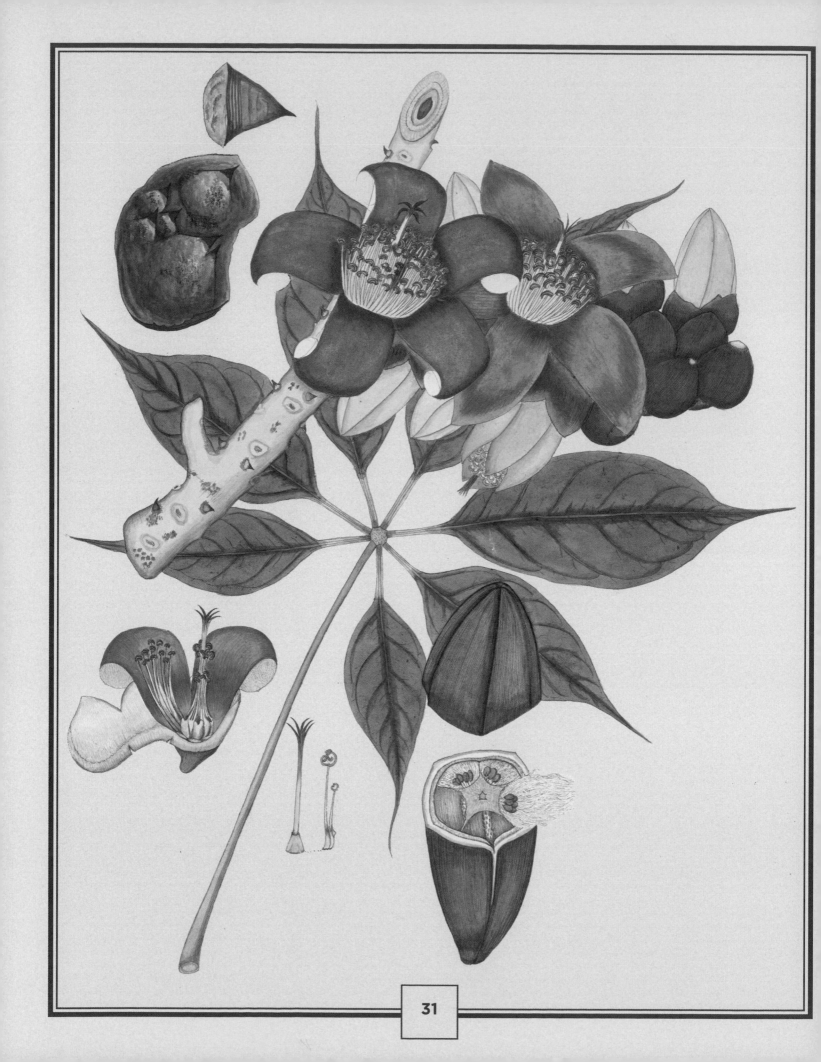

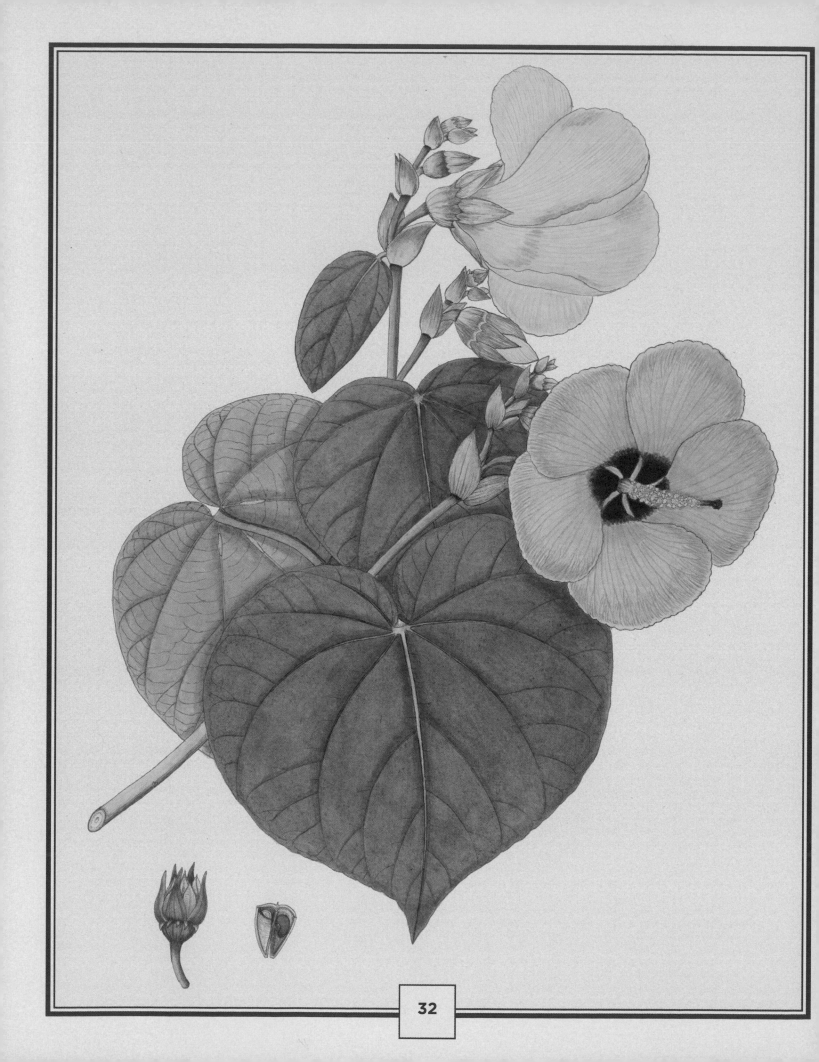

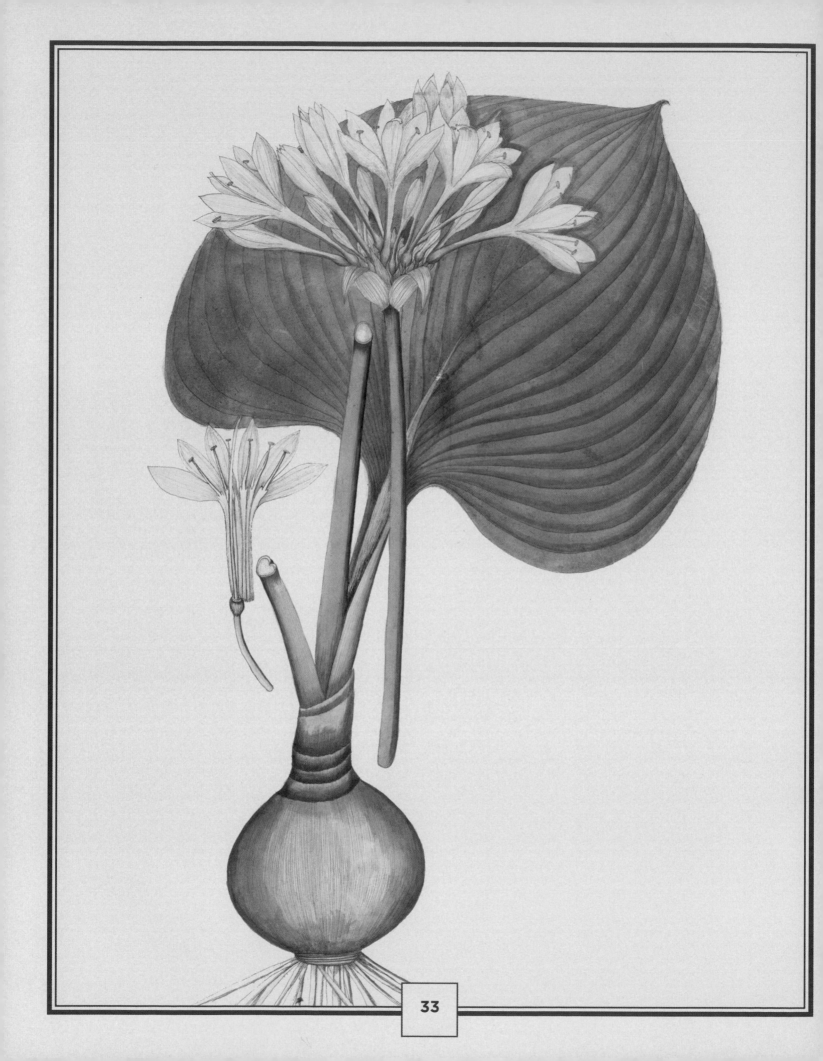

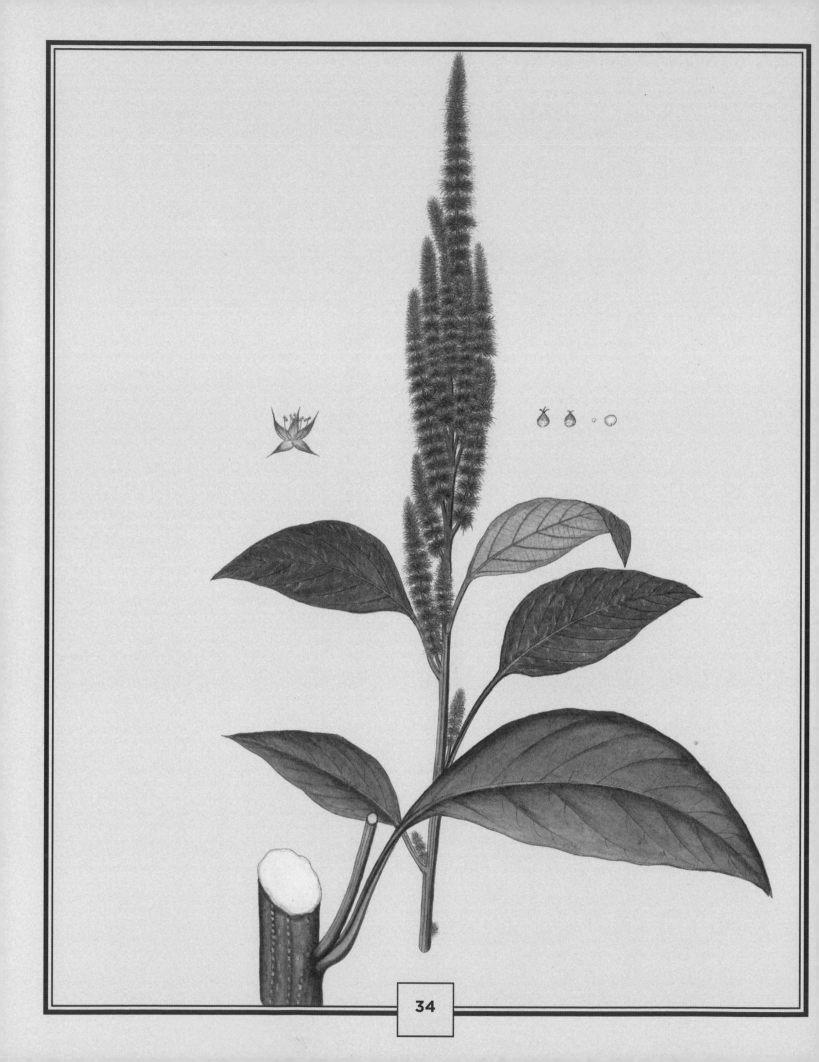

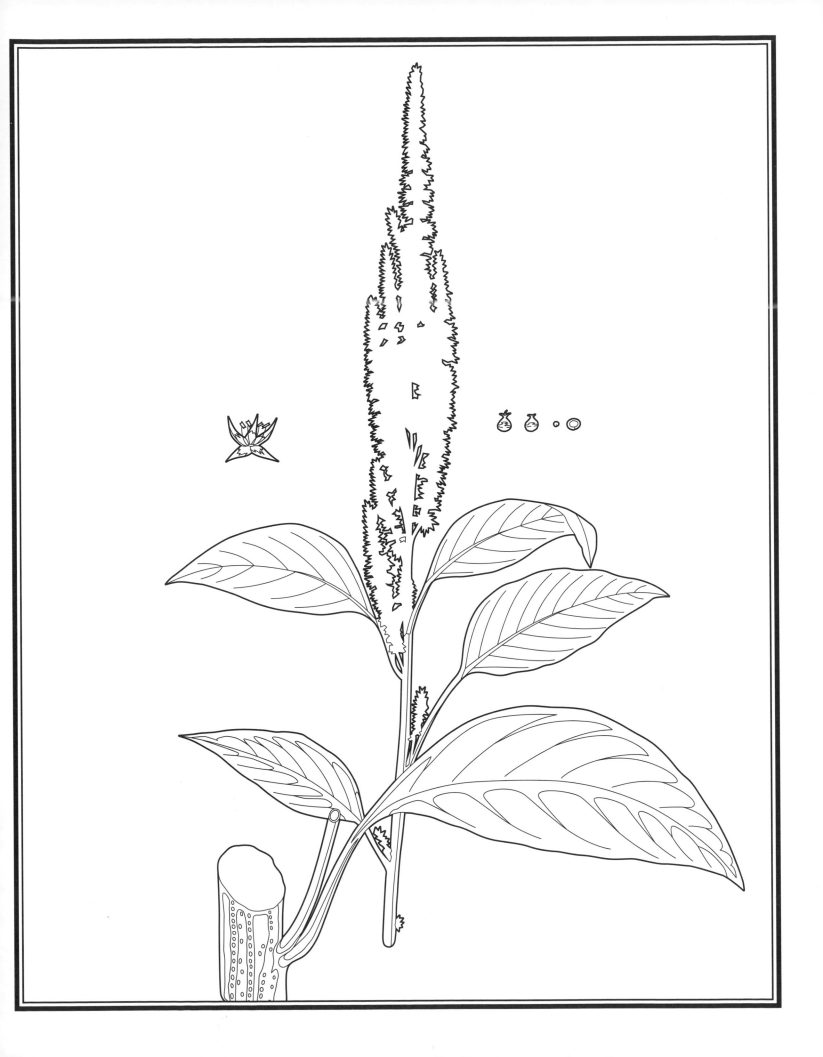

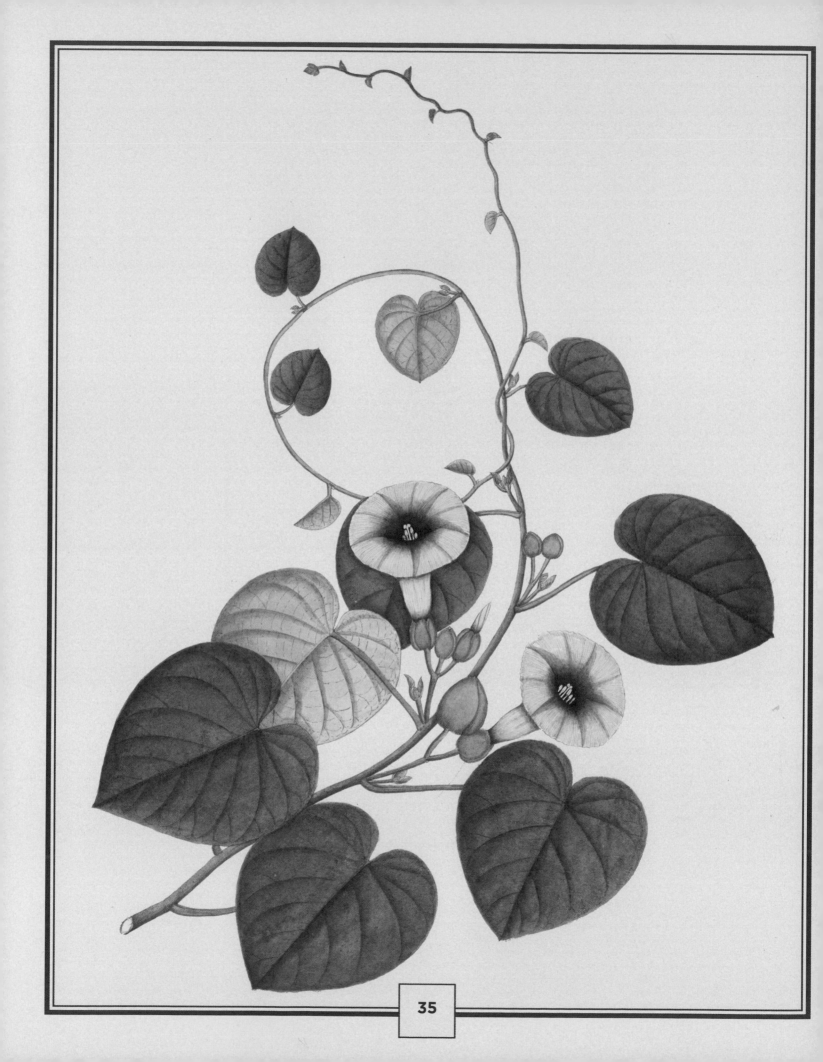

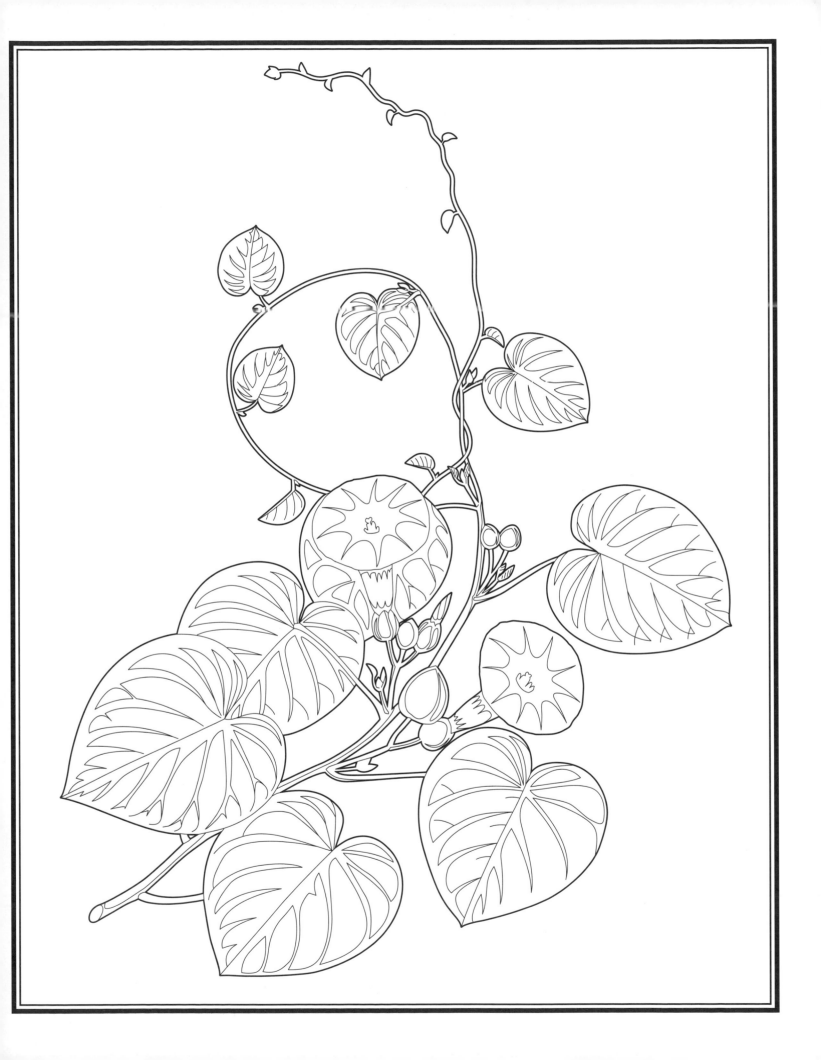

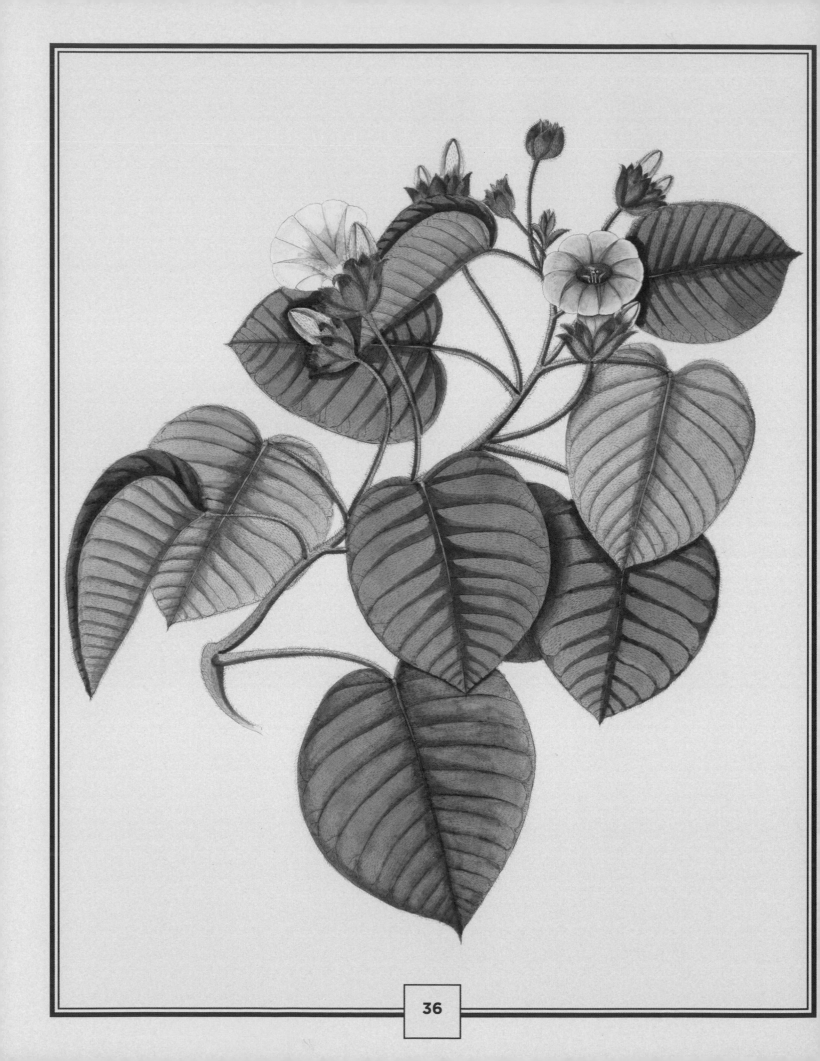

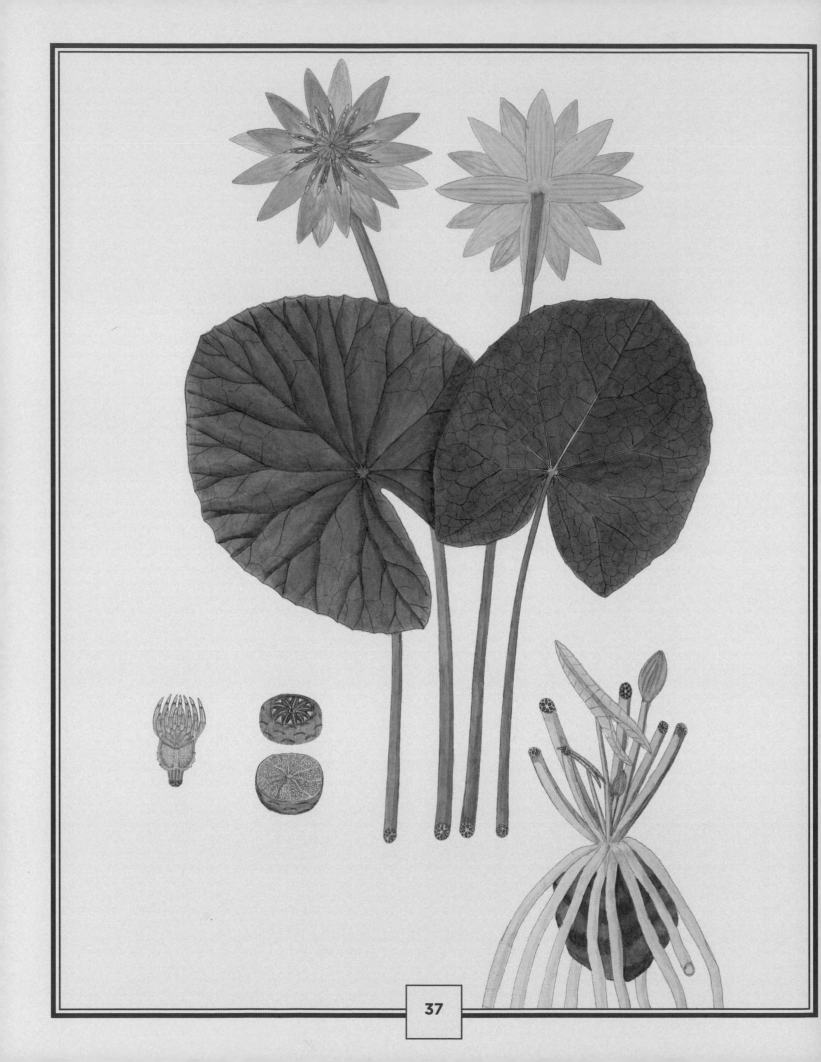

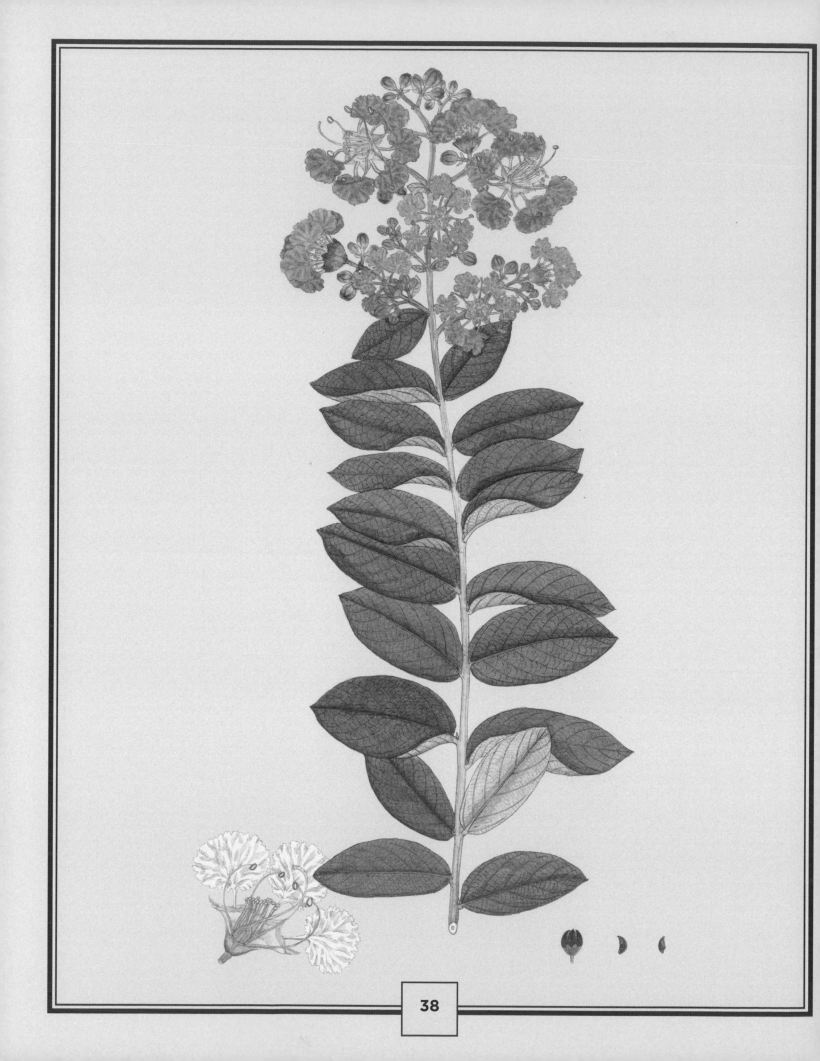

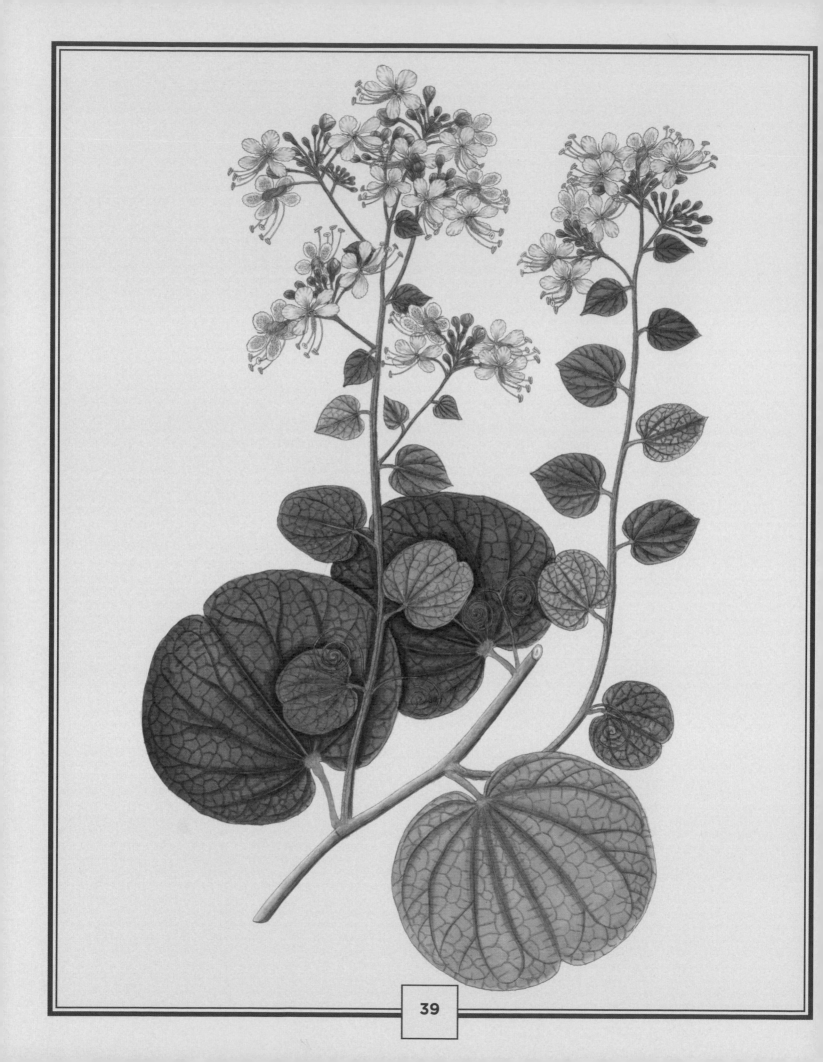

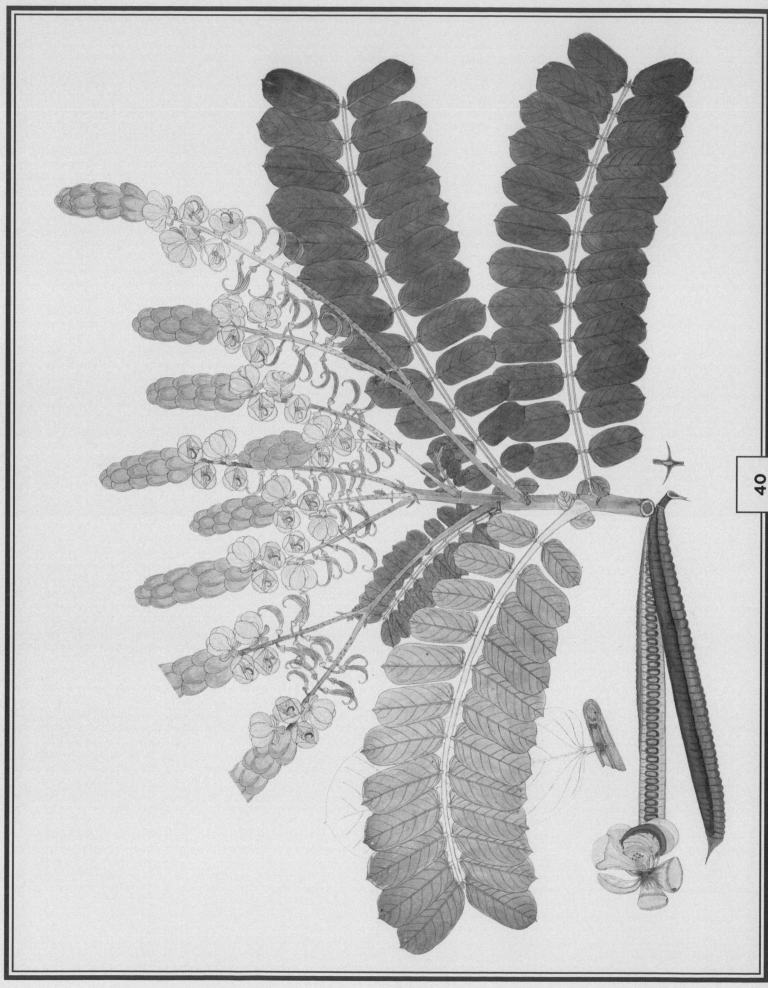

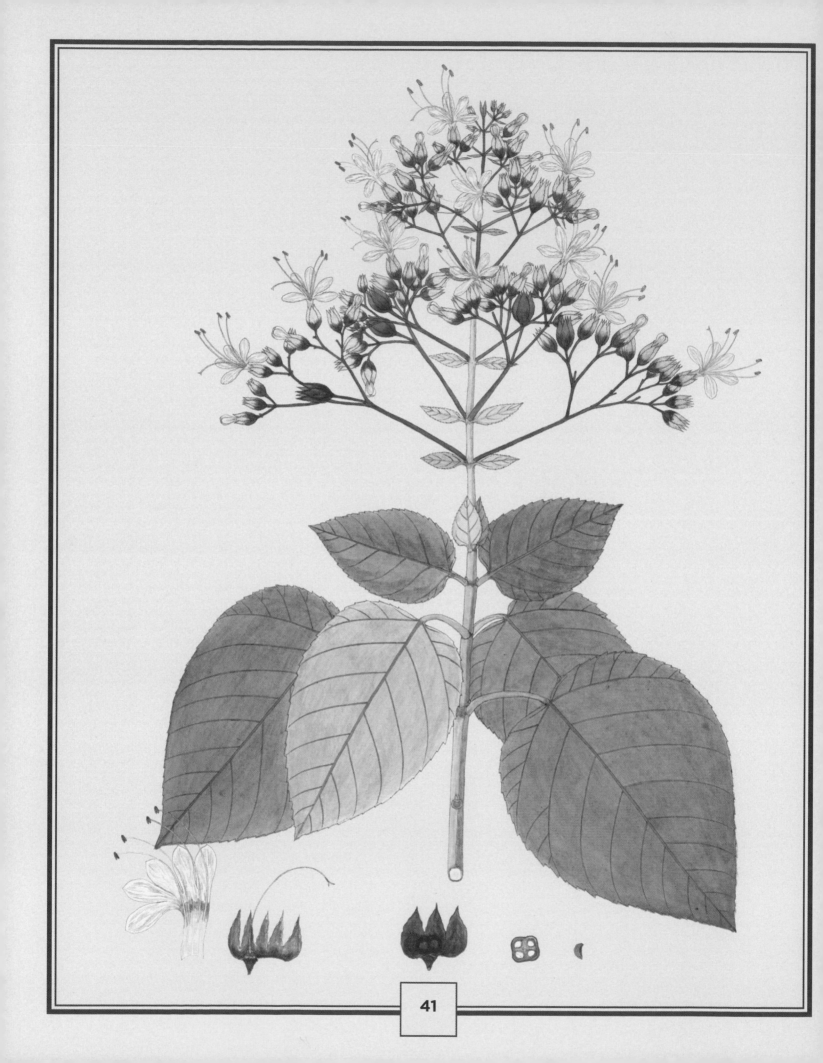

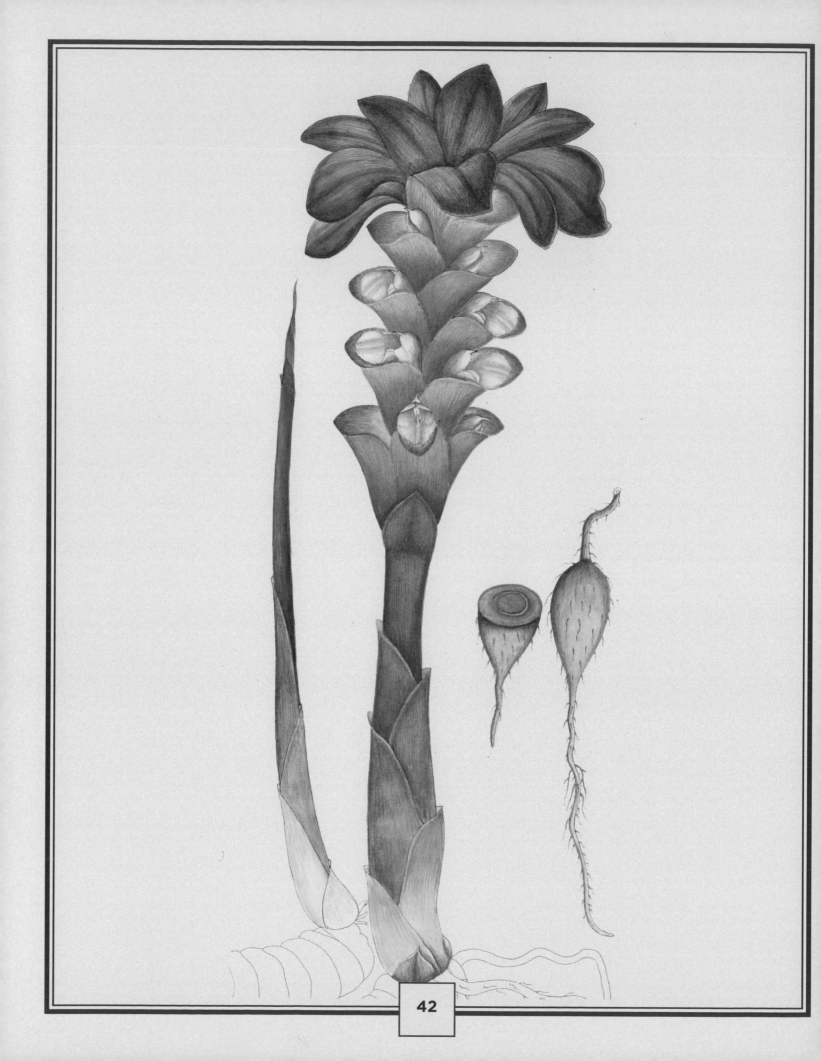

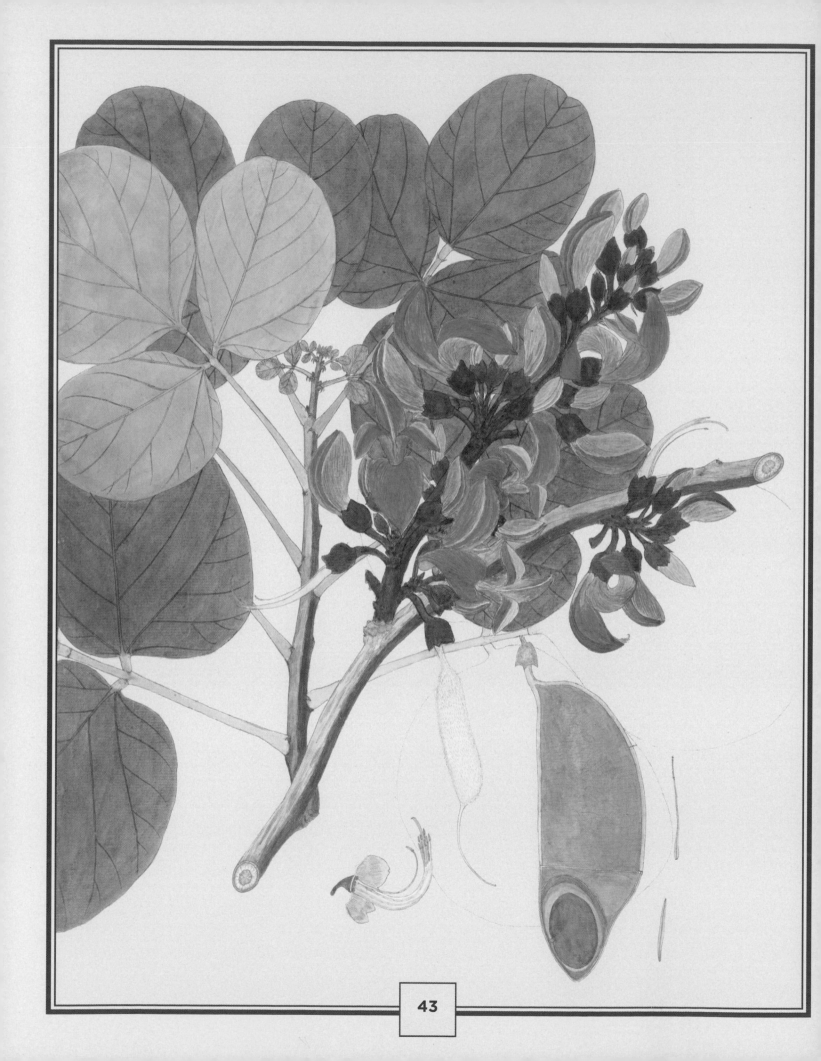

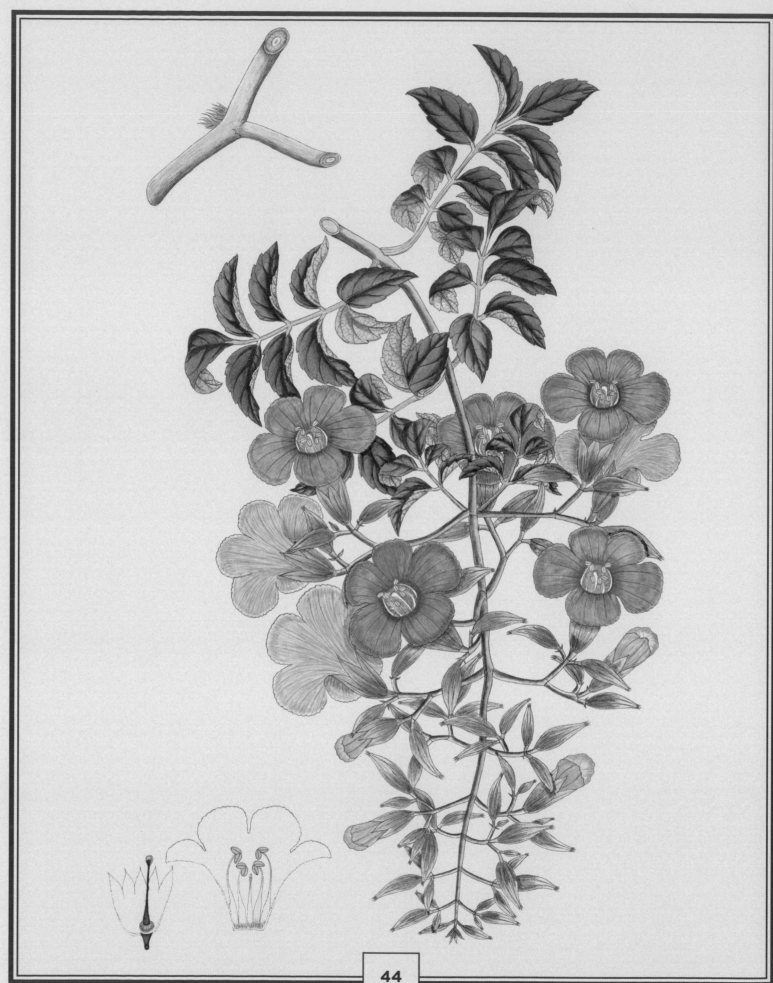

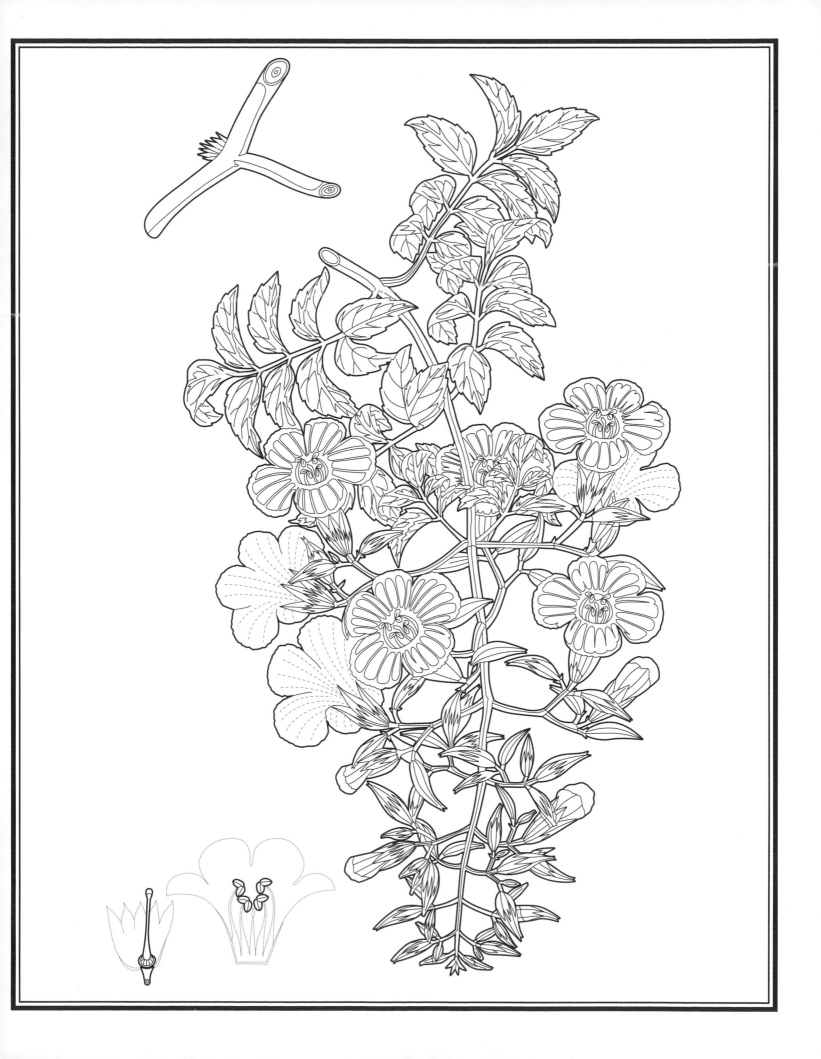